IMAGES
of America

KURE BEACH

IMAGES
of America

KURE BEACH

Brenda Fry Coffey

ARCADIA
PUBLISHING

Published by Arcadia Publishing
Charleston, South Carolina

Library of Congress Control Number: 2017949028

For all general information, please contact Arcadia Publishing:
Telephone 843-853-2070
Fax 843-853-0044
E-mail sales@arcadiapublishing.com
For customer service and orders:
Toll-Free 1-888-313-2665

Visit us on the Internet at www.arcadiapublishing.com

This book is dedicated to my lifelong friends Punky and Jean Kure. My sincere thanks for the hours researching pictures and reliving memories to make this book a possibility.

CONTENTS

ACKNOWLEDGMENTS

It is with humility that I extend my gratitude to everyone that entrusted their personal family pictures to my care.

Thank you for your encouragement, enthusiasm, and unfailing support over many months. Many thanks go to the following: Bubba Atkinson, Wayne Bowman, the Bullard family (Debbie, Cathy and Nancy), Nancy Faye Craig, the Davis family (Eleanor, Wilbur and Graham), the Flowers family (Marie, Linda and Johnny), Bobby and Elizabeth Ford, Isabelle Lewis Foushee, Shirley Garnes, Elaine Henson, Howard Hewett, Punky and Jean Kure, Mitsn Bartlett Mitchell, David Parks, Ronnie and Dianna Pernell, Carolyn Russ Pole, Pat Robertson Rice, Mike Robertson, Thomas Russell, Gary and Julie Teague, Judy Brinkley Younts, and Jay Winner. A debt of gratitude is owed to Rebecca Taylor, Leslie, and Darlene Bright of the Federal Point Historic Preservation Society (FPHPS); New Hanover County Public Library; North Carolina Room (NHCPLNCR); Brunswick Town/Fort Anderson State Historic Site (BTFASHS); North Carolina Department of Cultural Resources (NCDCR); Kure Memorial Lutheran Church; and Kure Beach First Baptist Church. Angel Hisnanick, title manager at Arcadia Publishing, has certainly been my angel. She has been, professional, kind, and always responsive to my many questions. Thank you for your guidance.

A thank-you is due to our daughter Karen Clark, granddaughters Sarah and Sydney Clark, and Julien Chomette for their words of encouragement and for all the technical support.

A special thank-you is given to my husband, Dan, for his assistance, support, humor, and endless patience.

It has been an honor to have the privilege of glancing into the past and recording our memories for the future.

INTRODUCTION

Over the years, many stories, some true and some a little stretched, have been told about inhabitants of our area. While it is true we have had a few eccentric citizens, they were always ours, and no one could talk about them except in a kind way.

Giovanni da Verrazzano is most commonly thought to have been the first European to visit the Cape Fear River. He arrived at the American continent off Cape Fear in early March 1524. After a short stay, he briefly sailed south and then turned north, sailing along the Atlantic shore. He entered and anchored in New York Bay on April 17, 1524, and named the harbor Angouleme after a dukedom that belonged to the king. He returned to Dieppe, France, arriving on July 8, 1524. While in the Cape Fear area, he saw towering pine trees, good land for farming, and wild grapes for wine. He also encountered a group of people that already knew about the wealth of the land. They were described as friendly and had thick black hair, which they tied at the back in a knot. They wore grass girdles that were woven with animal tails and hung around the body as far as the knees with the rest nude. They were of dark color, not unlike the Ethiopians. A glowing description was delivered to King Francis I of France, but no one returned until 1526.

Lucas Vázquez de Ayllón and 500 Spaniards entered the Rio Jordon (assumed to be the Cape Fear River) in 1526. While entering the river, they wrecked one of their vessels. The replacement ship, which was constructed on the lower part of the Cape Fear River, is believed to be the first ship built by Europeans in the United States.

After Ayllón left this area, almost a century and a half passed before the English arrived. King Phillip II of Spain decreed, in 1561, that no further steps were to be made to colonize Florida, as the territory was then known. Queen Elizabeth I opened the way for English colonization by stating the right of the British to conquer and occupy land "not actually possessed by any Christian prince or people. The Spanish called the Cape Fear area "Cape San Romano."

William Hilton arrived on the scene in 1662 and established a small colony that quickly became dissatisfied and departed. The cattle they left behind were kept by the Indians. The land was renamed Carolina by the Lord's Proprietors, and William Hilton again explored the region, but this time for the British Colony of Barbados. While here, he purchased the surrounding land from the Indians. Little is known of this tribe, not even the name they used for themselves, and so, some call them the Cape Fears Indians. The last Indian sighting was at Sugar Loaf in 1730.

The rich history of the area continued with an early ferry that operated between Brunswick Town on the west bank of the Cape Fear and the area near Sugar Loaf on the eastern bank. This ferry was very important for travelers going south to Charleston and north to Philadelphia and New England. This ferry was called the *Haulover*.

In the 1700s, pirates roamed the coastal waters, causing havoc, and our coastline provided unique hiding places. Many stories have been told about hidden treasures near freshwater lakes and under towering trees and the ghosts that protect their bounty. Piracy came to an end with the death of Stede Bonnet in Charleston, South Carolina, and Blackbeard at Ocracoke, North Carolina, in 1718.

The American Civil War came to our shores in the 1860s with the construction of Fort Fisher, which was named for Col. Charles Frederick Fisher. Colonel Fisher was from Rowan County and was killed in 1861 at the First Battle of Bull Run, making him an early hero of the Confederacy. Fort Fisher was modeled on the Malakoff Tower, a Russian redoubt at Sabastopol that withstood a land and naval attack during the Crimean War. Fort Fisher was termed the "Malakoff Tower of the South" as well as the "Gibraltar of the South." The last major stronghold of the Confederacy, Fort Fisher fell to Union troops on January 15, 1865.

After the Civil War, the Federal Point peninsula saw major changes. Hans Anderson Kure Sr. established the Kure Land and Development Company to develop Fort Fisher Sea Beach, later called Kure Beach, in the early 1900s. After his death in 1914, he left his holdings to his wife who later passed them on to their children. In 1916, the Kure Company gave substantial money to construct a road into Kure Beach. The road had the distinction of being the only automobile highway in North Carolina leading directly to the ocean. The roadbed was constructed of Lillington gravel and coquina rock from Fort Fisher and is known as Dow Road. The road cost approximately $4,500 per mile and was the most permanent and handsome stretch of road in the county.

The steamers *Wilmington*, *Sylvan Grove*, *Passport*, *Louise*, *Lucille*, *Minehaha*, *Bessie*, *Clarence*, and the *Southport* were among the many ships that kept the Cape Fear River alive with sails. Some carried passengers to our area for swimming, fishing, and just relaxing. The captains of these vessels were mostly described as generous, jovial, and popular, and some had been in command of blockade runners.

In 1923, Lawrence C. Kure built the first wooden fishing pier on the Atlantic coast. This pier has been in continuous operation for 94 years, making it also the oldest pier on the Atlantic coast. Bill Robertson, son-in-law of Lawrence Kure, purchased the pier in 1952. That year, the pier doubled the number of fishermen since 1923. The crowds were even larger the second year. At times, the pier had to be roped off because there were too many fishermen. Bill took a survey and determined that 80,000 fish had been caught from the pier in one day. He knew no one would believe it, so he cut the figure in half and wrote a story saying 40,000 fish were caught. No one believed that story either. Mike Robertson, Bill's son and Lawrence's grandson, is the current owner of the pier.

In 1931, the peninsula became an island with the construction of Snows Cut, which was part of the proposed intracoastal waterway system. This cut is named for Maj. William Snow, who was the district engineer for this project. A swing bridge connected the newly formed island with the mainland and was the only way on and off the island.

The Kure Beach Progressive Association was formed on December 31, 1945, for the purpose of improving conditions at Kure Beach. Concerns included fire protection, garbage collection, sanitation conditions, and streetlighting. There was great interest among the permanent and summer residents, and 55 people volunteered their services. Money was raised by community turkey dinners, and funds were pledged by individuals to secure a fire truck with necessary equipment and to improve drainage, water, and electrical services. Lawrence Kure said he would provide water and fittings if volunteers would help equip them. He also donated land for a fire department, and a building was located to house the equipment. This association paved the way for the incorporation of the Town of Kure Beach in 1947.

In 1952, Dr. Claude Henry Fryar, his wife, Lucie Hayes Fryar, and their daughters, Ida, Frances, Lucie, and Betty moved to Carolina Beach. He was the first doctor to have his practice and residence on the island. His office was at Carolina Beach, and he made house calls all over the island. Lawrence Kure was one of his many patients. Dr. Fryar died of a heart attack eight months after moving to the area. His stay was brief, but he is still remembered.

The town seal, consisting of a beach scene, pier, and umbrella, was officially adopted by the town council in 1991 and was designed by Phil Niedens, son of Ed and Linda Niedens.

The area known as Kure Beach has changed over the years from dirt roads, open windows, thick maritime forest, sandburs, deserted beaches, and quiet nights to a modern town with technological conveniences and a greater population. Growth is inevitable, when the area is so peaceful and beautiful, but we still retain our small-town flavor. Neighbors still talk and visit, always giving a helping hand when sickness or death occurs; joys are shared; meals bring people together; and everyone unites to preserve our blessed lifestyle.

One

PENINSULA HISTORY
1524–1865

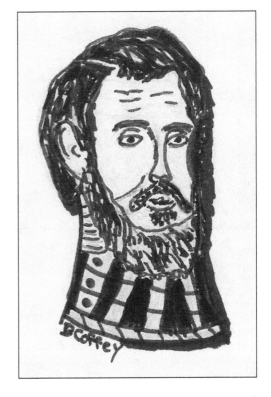

Giovanni da Verrazzano, an Italian navigator in the service of Francis I of France, is most commonly thought to be the first European to visit the Cape Fear River. In January 1524, he and his brother Girolamo, who served as navigator and cartographer, sailed from Spain. His three-masted flagship *La Dauphine* was piloted by Antoine de Conflans. The ship could hold approximately 50 people. (Sketch by author.)

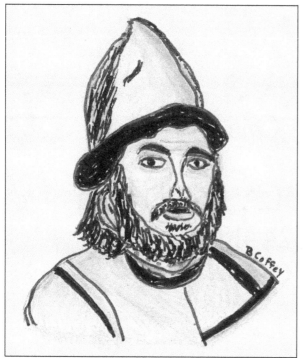

In 1526, Lucas Vásquez de Ayllón and about 500 Spaniards entered the Rio Jordon (Cape Fear River) and wrecked one of their vessels. The replacement ship, constructed on the lower part of the Cape Fear, is believed to be the first ship built by Europeans in the United States. After Ayllón left the area then named Cape San Romano, almost a century and a half passed before the English arrived. (Sketch by author.)

William Hilton, representing the Massachusetts Bay Colony in 1662, was sent to explore the area for suitable places to inhabit. He gave a favorable report, and in late 1663, the New England settlers arrived. They quickly became dissatisfied and departed four months later. On his second trip, representing the British Colony of Barbados, he named the area "Cape Fear." He remained three weeks and purchased land from the Indians. (NHCPLNCR.)

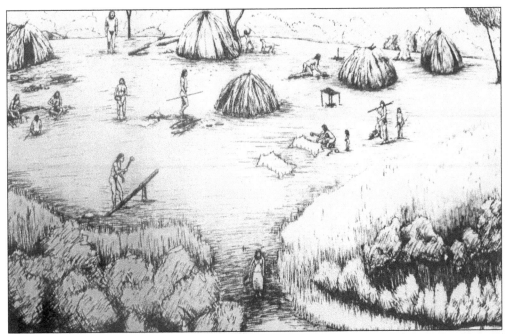

Scholars believe the indigenous people encountered by Verrazano and William Hilton became known as the Cape Fear Indians. They inhabited present-day New Hanover and Brunswick Counties. It is believed they spoke a Siouan language, making them distant cousins of the Plains Sioux. Relying on coastal estuaries for food, the Cape Fear Indians used seines in the sounds to trap small fish and harvested oysters and clams. In addition, they also raised vegetables such as beans and corn. (NHCPLNCR.)

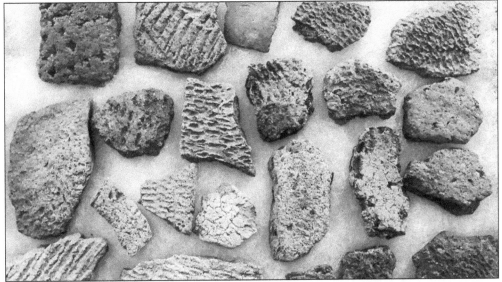

No religious totems of the Cape Fear Indians have been found; however, pottery shards, stone tools, and a few dugout canoes have been identified. Three major Indian trails existed, and the modern-day paths of highways US 421 and US 17 North and South follow them. The oldest positively dated Indian campsite in the county was inhabited about 1,600 years ago near Middle Sound. (Jay Winner.)

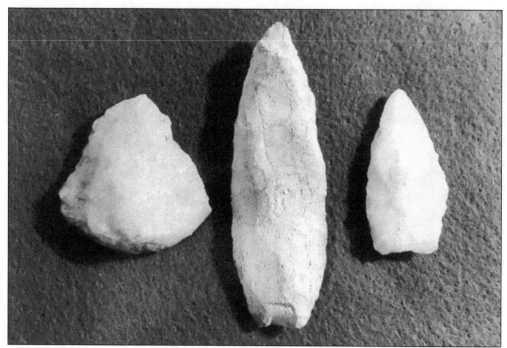

The Cape Fear Indians hunted extensively in coastal swamplands, stalking deer, bears, turkeys, and game birds with bows and arrows. Tradition says the last Indian battle, led by Col. Maurice Moore and a band of Tuscarora Indians in 1715, was fought at Sugar Loaf, north of Kure Beach. The Indians abandoned Cape Fear around 1725, although some were seen at Sugar Loaf in 1730. (Coffey family.)

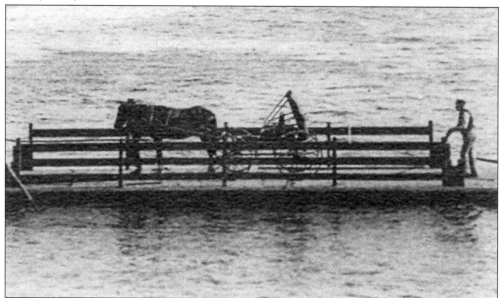

In 1726, Cornelius Harnett Sr. opened an inn and ferry at Old Brunswick Landing on the western bank of Cape Fear River. His ferry landed at the "Haulover," located at Big Sugar Loaf on the eastern bank of the river and connected with the only road to the northern part of the province. This picture depicts how the ferry may have looked. (NHCPLNCR.)

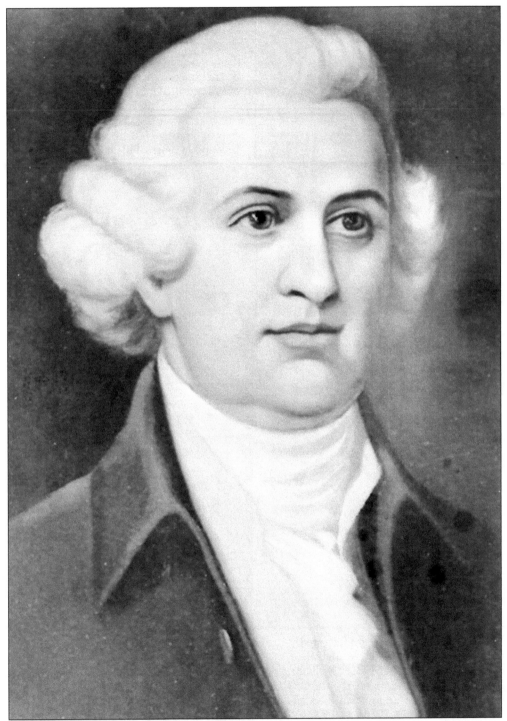

The Federal Point peninsula remained relatively quiet during the Revolutionary War except for local Wilmington resident William Hooper's participation in the signing of the Declaration of Independence and a slight skirmish in Buzzards Bay at the southern tip of the peninsula. (NHCPLNCR.)

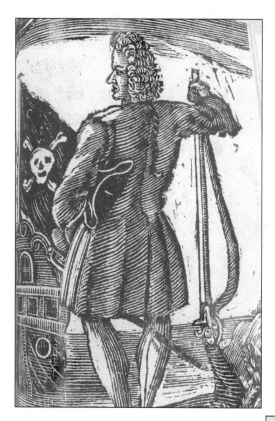

North Carolina's southern coastline was a pirate's utopia. The inlets between sandbars allowed the shallow draft vessels to escape the heavy men-of-war ships. Maj. Stede Bonnet (pictured), the gentleman pirate, was ill qualified for this business. He not only purchased his ship, the *Revenge*, but paid his crew. It is said that his reason for going a-pirating is due to some discomforts he found in married life. (NHCPLNCR.)

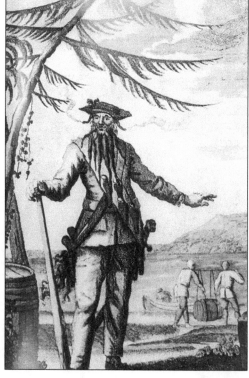

With the death of Blackbeard (pictured) in November 1718 at Ocracoke and the capture of Stede Bonnet by Col. William Rhett near Bald Head Island, the threat of piracy in North Carolina vanished. In December 1718, Stede Bonnet walked to the gallows in Charleston, South Carolina, with a nosegay in his manacled hands. He was given a pirate's burial, below the low-tide mark. (Engraving by James Basire, 1730.)

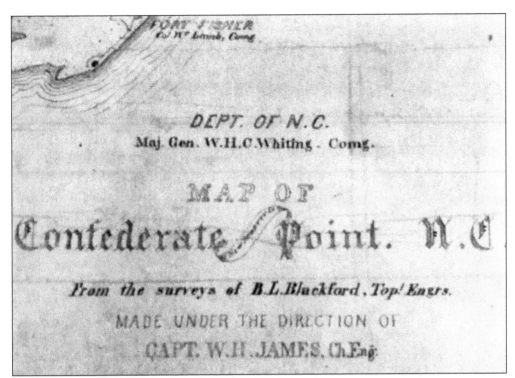

DEPT. OF N.C.
Maj. Gen. W.H.C. Whiting. Comg.

MAP OF

Confederate Point. N.C

From the surveys of B.L.Blackford, Top! Engrs.

MADE UNDER THE DIRECTION OF

CAPT. W.H. JAMES, Ch.Eng:

People began calling the peninsula Federal Point in the 1790s in honor of the new federal government and the ratification of the US Constitution by North Carolina in 1789. A map engraved by Joshua Potts about 1797 shows Federal Point by name. During the Civil War, it was renamed Confederate Point, but after five long years of war, the name again reverted to Federal Point. (NHCPLNCR.)

Col. Charles Frederick Fisher was born on December 26, 1816. He was an attorney, North Carolina state senator (1854–1855), engineer, president of the North Carolina Railroad (1855–1861), and a soldier from Rowan County. He was educated at Yale University. During the Civil War, he commanded the 6th North Carolina Regiment. His gallantry leading a charge on a Union Army battery at the First Battle of Bull Run cost him his life on July 21, 1861, and made him an early hero of the Confederacy. Fort Fisher was named for him. (Sketch by author.)

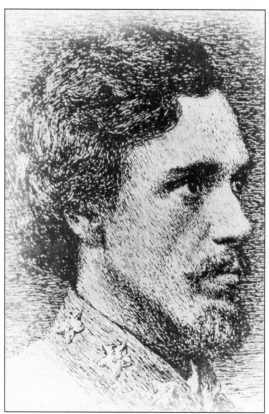

Colonel Lamb, a lawyer, editor, merchant, and politician from Virginia, assumed command of Fort Fisher in 1862 and immediately recognized its value to the Confederacy. For three days, he and 1,900 men defended the South's largest bastion against 10,000 Federal land troops and a Union Naval blockade. Fort Fisher fell to the Union on January 15, 1865. The Federal Army, although victorious, lost more men than Colonel Lamb. (FPHPS.)

Confederate Point was heavily fortified. The Cape Fear River inlets were kept open for the blockade runners to bring desperately needed war materials and supplies to Port Wilmington. Fort Fisher, known as "the Gibraltar of the South," was the largest coastal fortification in the Confederacy and an engineering marvel. (Kure family.)

16

Fort Fisher overlooked the Cape Fear River on one side and the Atlantic Ocean on the other. Confederate soldiers, in their network of batteries and entrenchments, resisted throughout the war, and the Cape Fear inlets were the last major supply points to fold after fierce battles at Fort Fisher in January 1865. (BT/FAHS.)

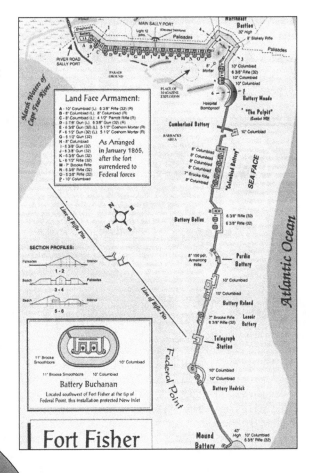

Land Face Armament:

A - 10" Columbiad (L); 6 3/8" Rifle (32) (R)
B - 8" Columbiad (L); 8" Columbiad (R)
C - 8" Columbiad (L); 4 1/2" Parrott Rifle (R)
D - 5 7/8" Gun (32); 6 3/8" Gun (32) (R)
E - 6 3/8" Gun (32) (L); 5 1/2" Coehorn Mortar (R)
F - 6 1/2" Gun (32) (L); 5 1/2" Coehorn Mortar (R)
G - 6 1/2" Gun (32)
H - 8" Columbiad
I - 6 3/8" Gun (32)
J - 6 3/8" Gun (32)
K - 6 3/8" Gun (32)
L - 6 1/2" Rifle (32)
M - 7" Brooke Rifle
N - 6 3/8" Rifle (32)
O - 6 3/8" Rifle (32)
P - 10" Columbiad

As Arranged in January 1865, after the fort surrendered to Federal forces

SECTION PROFILES:

Battery Buchanan
Located southwest of Fort Fisher at the tip of Federal Point, this installation protected New Inlet

Fort Fisher

Rose O'Neal Greenhow, born in 1813, was a renowned Confederate spy. She cultivated friendships with the elite of Washington, DC, and passed key military information to the Confederacy at the start of the war. She was captured by the Union in 1862 and imprisoned for five months. She was later released and deported to the Confederate states. She became a representative of the Confederacy in Britain and France. (NHCPLNCR.)

On August 19, 1864, Rose O'Neal Greenhow left Europe, aboard the British blockade runner *Condor*, to return to the Confederacy. She carried dispatches and $2,000 worth of gold sewn into her clothing. On October 1, 1864, the *Condor* ran aground at the mouth of the Cape Fear River while being pursued by the USS *Niphon*, a Union gunboat. Fearing capture and reimprisonment, she fled the grounded ship by rowboat. A wave capsized the rowboat, and she drowned, weighed down by the gold she was carrying. Her body washed ashore and was prepared for burial by Daisy Lamb, wife of Colonel Lamb. Her gold, which had been stolen, was later recovered. She was honored with a military funeral and buried at Oakdale Cemetery in Wilmington, North Carolina. (NHCPLNCR.)

Two

KURE BEACH HISTORY
1800–1910

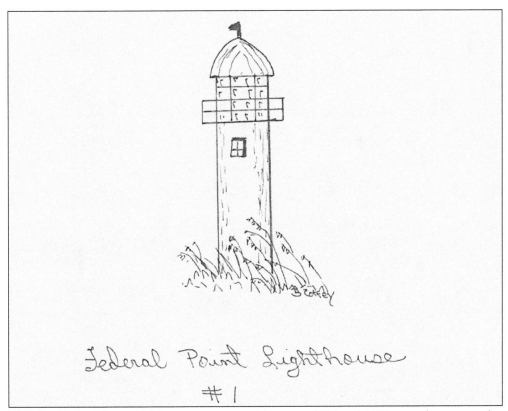

Federal Point Lighthouse
#1

The first Federal Point lighthouse was erected between 1816 and 1817 near the present-day monument at Fort Fisher. The 40-foot beacon was conical and brick. It had a shingled roof and three floors with ladders for climbing. The outside was plastered and white-washed. No pictures or records have survived. It was destroyed by fire in 1836. (Sketch by author.)

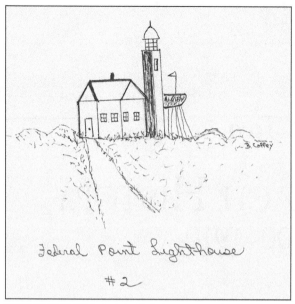

The second brick lighthouse was conical and constructed in 1837. It had a base of 18 feet and a height of 30 feet. The light came from 11 patent lamps, each with a 14-foot reflector. A 34-by-20-foot keeper's house with a five-by-four-foot outhouse was also constructed. The cost was $4,845. The first light keeper recorded was James L. Newton. This lighthouse was dismantled in 1863. (Sketch by author.)

Federal Point Lighthouse #2

Federal Point Lighthouse #3

The third lighthouse was constructed in 1866. A square two-story wooden frame house was built on pilings with the light on its roof. The cast-iron light was surrounded by an octagonal walkway that provided access for lighting and cleaning of the lanterns. It was also in a new location near the beach access and the state park ranger's offices. It remained in use until 1881. (Sketch by author.)

Wilmington was an important seaport, and mariners would navigate the natural channel from the mouth of Cape Fear to Wilmington, but shoaling occurred very quickly, especially when fueled by frequent storms. This shoaling changed the navigation channel for the ships, causing ships to be grounded or sunk. A rock retaining wall was built by the Army Corps of Engineers in an effort to hold back the sand from drifting into the shipping channel. This photograph shows the "Rocks" at the end of Highway 421. Work on completely closing New Inlet began in 1874 by placing cribwork along a 1,700-foot-long line of shoals to the channel. This consisted of a line of wooden mattresses, composed of logs and brushwood, loaded with stone, and sunk, which formed the foundation of the dam to Zeke's Island. The closing of New Inlet was successfully completed in 1881. (FPHPS.)

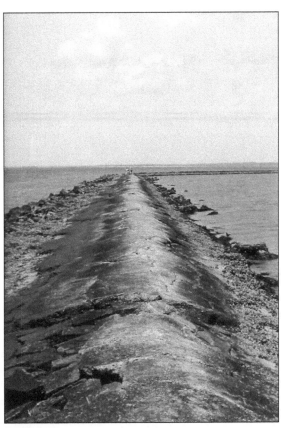

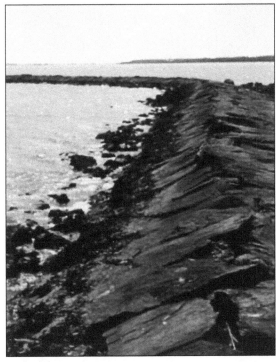

The Rocks measure 90 to 120 feet wide at the base. The upper section of the dam extends from Battery Buchanan to Zeke's Island, a distance of 5,300 feet, and from Zeke's Island to Smith's Island, 12,800 feet, to make the entire closure just over three miles in length. The project was completed in 1891. The US Army Corps of Engineers topped the Rocks with concrete during the 1930s. The project unintentionally helped develop one of the richest salt marshes on the coast, and 1,500 acres of this 8,000-acre salt marsh has become part of the National Estuarine Research Reserve. (FPHPS.)

Henry Nutt, chairman of the Committee on River and Bar Improvement, was the first to walk across the Rocks in June 1879. He walked a mile from Federal Point to Zeke's Island, with his grandson William M. Parsley. When he was halfway across, he was saluted with three cheers from about 60 laborers engaged in throwing stones. One can see the Rocks in the background of this present-day photograph. (Rebecca Taylor.)

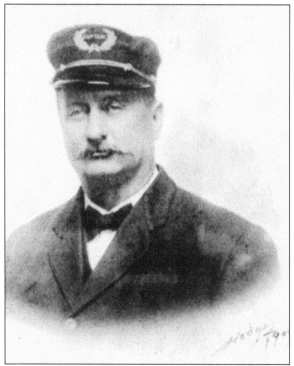

John Harper was born on November 28, 1856. He was the first person to refer to New Inlet Dam as the "Rocks." He was also the first to take excursion passengers to that point of interest. He piloted the steamers *Wilmington*, *Passport*, and *Sylvan Grove*, among others. He was a jovial, popular gentleman and was known by his generous deeds as well as his considerable skill as a riverboat captain. He died on September 18, 1917. (Elaine Henson.)

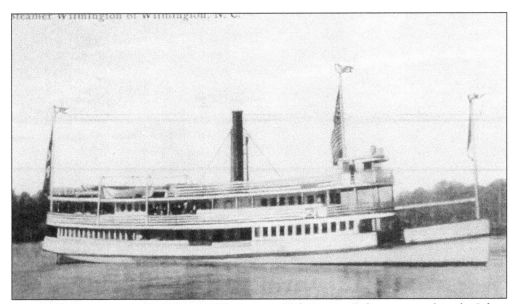

Captain Harper purchased the steamer *Wilmington* in Wilmington, Delaware, to replace the *Sylvan Grove*. She had three decks and room for 500 passengers to dance. The price of a ticket was 50¢ for adults and 25¢ for children. She made excursions from Wilmington to Carolina Beach and later to Kure Beach. The ship was sold in 1926 to a company in Florida. (FPHPS.)

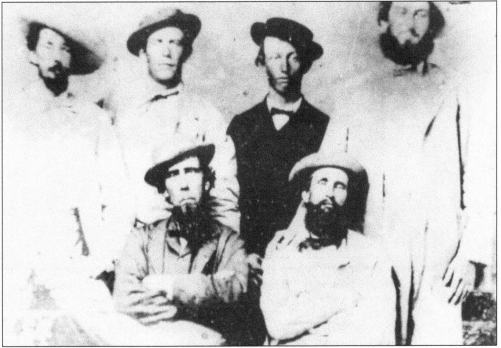

Pictured are some of the Cape Fear River pilots in the late 1800s. From left to right are (sitting) Thomas Newton and Julius Dosher; (standing) Joseph Newton, unidentified, Joseph Bensel, and Thomas Brinkman. Several of the men were successful Civil War blockade runners. Many of the river pilots, such as Thomas Brinkman and Joseph Bensel, died in the performance of their duties in hazardous conditions. (NHCPLNCR.)

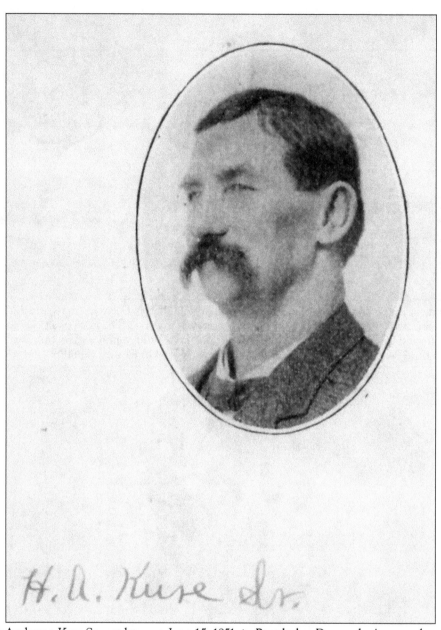

H. A. Kure Sr.

Hans Anderson Kure Sr. was born on June 15, 1851, in Bornholm, Denmark. At an early age, he went to sea as a cabin boy and later became a ship's captain. In the 1870s, his sailing vessel was wrecked off the North Carolina coast. Hans was rescued and placed in a hospital at Beaufort, North Carolina. After recovering, he returned to Denmark, but Beaufort had made a lasting impression. Shortly after returning to Denmark, he and his wife re-embarked for America. After a short stay in Charleston, South Carolina, they moved to Wilmington. In 1879, he opened a ship chandler/stevedore business. His first business venture on the peninsula was at Carolina Beach in 1891. In the early 1900s, he sold some of his holdings and purchased 900 acres, just south of Carolina Beach to Fort Fisher. The Kure Land and Development Company was established to begin development of Fort Fisher Sea Beach, which was later called Kure's Beach. Hans died on December 23, 1914. (Kure family.)

Ellen Mueller Kure was born March 7, 1851, in Copenhagen, Denmark. Before marrying Hans Anderson Kure Sr., Ellen was a lady-in-waiting at the Danish Court of Christian IX and spoke at least seven languages. Hans and Ellen's first born, Hans Anderson Jr. (1879), died in infancy. They reared four sons, William Ludwig (1881), Hans Adolph (1883), Lawrence Christian (1886), Andrew Emile (1893), and one daughter, Elene Margreth (1889). When her husband died in 1914, he left all his holdings to Ellen, who later passed them on to their children. Ellen died on December 30, 1928. (Kure family.)

This sketch of Capt. William Edward Lewis was made from an 1890 photograph. He and his wife, Georginna, moved to Federal Point in 1904 from Brunswick County. During the move when he was in the process of bringing the farm animals across the river on a sharpie schooner, he encountered a squall. The schooner capsized, resulting in his death. (Sketch by author.)

After the death of her husband, Georginna Andrews Lewis was left to raise their eight children, Addie Jane, Pearl, William, Shufford, Walker, Hattie, Crawford, and Edward, who was born after his father's death. Her home was on a bluff above the river at Fort Fisher and was accessed by a dirt road called "Jenny," which ran south from the sharp curve on Dow Road. (Howard Hewett.)

Pictured from left to right are (sitting) Sarah Ellen Hewett Henniker (George Henniker Sr.) and Minnie Hewett; (standing) Flossie Hewett Robinson (Ernest Robinson) and Rebecca Hewett Davis (John Davis). Their parents were Anson and Sarah Kirby Hewett. They lived at Fort Fisher in the 1900s. Farming, fishing, and raising cattle were a way of life for the few inhabitants of this area. (Howard Hewett.)

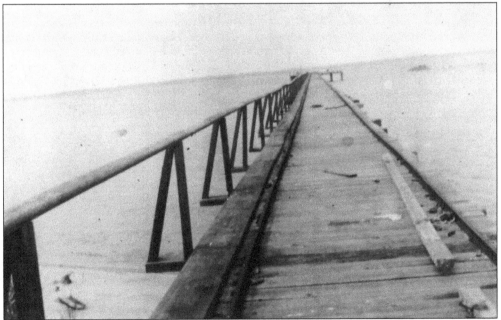

About 1904, Hans Sr. built a pier called "Kure Landing" on the east side of the Cape Fear River at Kure Beach. Two small steamers made daily trips upstream to Wilmington. One of these vessels was a handsome sloop named *Vim*, which the firm of Kure Brothers had purchased at auction. The vessel in the background is the *Swanee*, also owned by the Kures. (Kure family.)

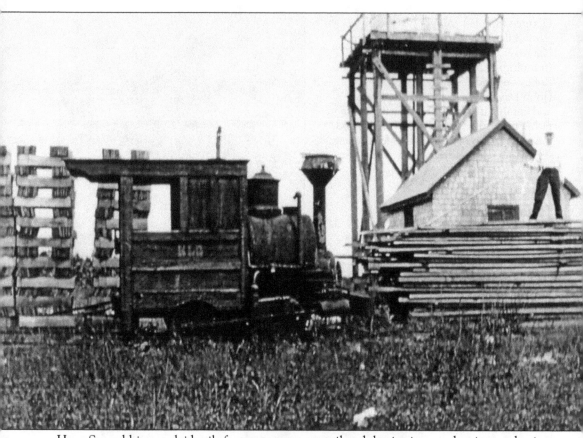

Hans Sr. and his sons laid rails for a narrow-gauge railroad, beginning on the river and going east across the peninsula to the ocean. The tracks followed a path between I and J Avenues and curved slightly to the north near the South Seas Motel. The train had between three and five flatcars and a small locomotive and was known as the Fort Fisher Railroad Company. Andrew E. Kure Sr. is pictured in 1905, standing on a stack of cedar, which will be transported by train across the peninsula for construction of new homes and businesses. (Kure family.)

Family and friends gathered at the home of Ellen Mueller Kure in 1910. Andrew Kure Sr. is pictured on the left, and the others are unidentified. The house was located on the east side of North Fort Fisher Boulevard in the vicinity of the present-day Seven Seas Motel. The cottage had two floors with a bathroom on each level. (Kure family.)

Andrew Emile Kure Sr. was born on March 30, 1893. He was the fifth son of Hans and Ellen Kure Sr. During World War I, he served with the American Expeditionary Force in France. He enlisted on December 15, 1917, and was discharged on June 9, 1919. This picture was taken at Fort Fisher around 1910. He died March 3, 1950. (Kure family.)

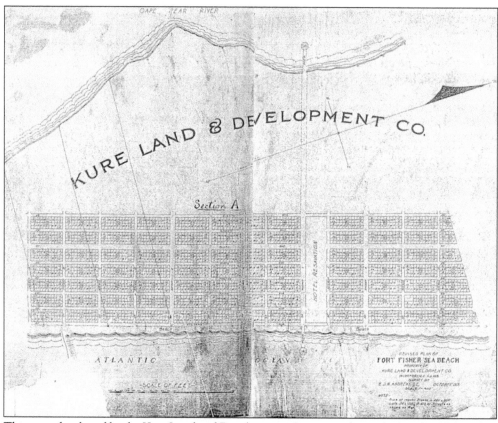

This map, developed by the Kure Land and Development Company, shows the layout of Fort Fisher Sea Beach in October 1913. Section A is laid out by lots from A Avenue, on the left, to M Avenue, on the right. The layout shows eight streets from the ocean toward the river. (Kure family.)

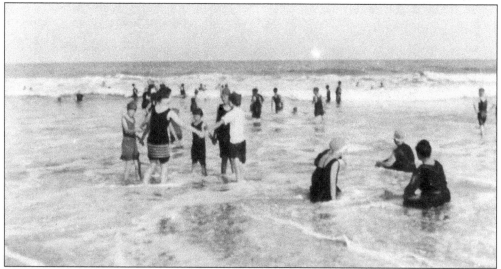

Here, people are shown playing in the Atlantic surf, 1913 style, at Fort Fisher Sea Beach, today's Kure Beach. Everyone is staying close to shore. Bathing caps and wool stockings were popular with the ladies, and the men wore jerseys. (Kure family.)

The Gen. Frank A. Bond house was built in 1915 and was located oceanfront at H Avenue and Fort Fisher Boulevard. General Bond visited Fort Fisher Sea Beach and was so impressed with the natural beauty that he bought a lot and built a handsome summer cottage. Pictured on the porch are Frank Hughes, General Bond, and Howard Hughes. (FPHPS.)

Standing outside their home at 314 Nun Street in Wilmington, North Carolina, are Anne (left), Ellen (center), and Laura Kure. This picture is dated June 15, 1916. Their parents were Hans Adolph and Jennie Kure. (Kure family.)

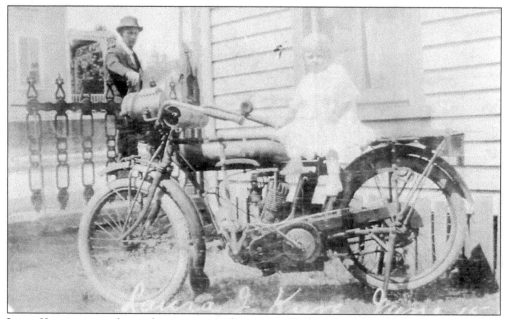

Laura Kure is pictured seated on a motorcycle on June 15, 1916. Lawrence C. Kure is pictured on the left. (Kure family.)

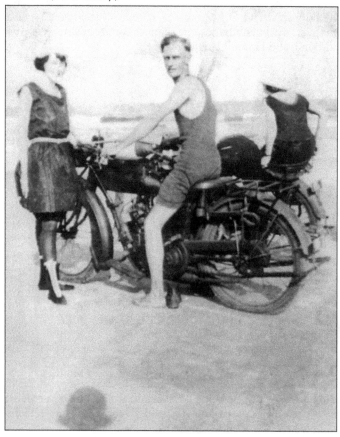

This picture is dated August 5, 1916, at Fort Fisher Sea Beach. The bike in the background belonged to Walter Winner, and the other one belonged to the seated A.E. Kure Sr. The ladies are unidentified friends. (Kure family.)

Three

KURE BEACH HISTORY
1920s–1930s

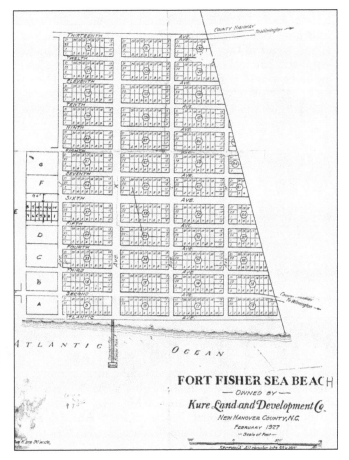

This map dated February 1927 shows the town as having 13 streets. The Kure Land and Development Company decided to confine the development activity to Section A. The remainder would be developed in stages. They had already constructed six miles of board sidewalks, divided the section into lots, and constructed a pavilion, fishing pier, and other buildings, including a bathhouse. (Kure family.)

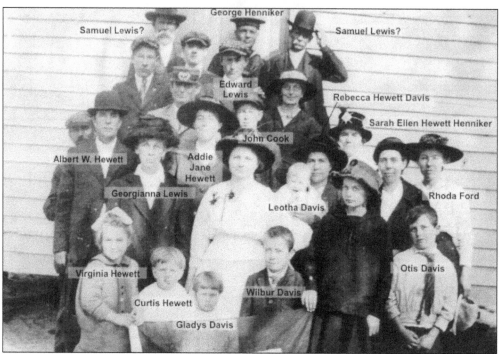

Pictured is a gathering at Federal Point Methodist Church in 1926. The church was located in a grove of trees off Dow Road. The man identified as John Cook is Edward Lewis, and the man identified as Edward Lewis is John Cook. The lady to the left of Rhoda Ford is her sister Minnie. One of the men identified as Samuel Lewis is actually Henry Lewis. (Howard Hewett.)

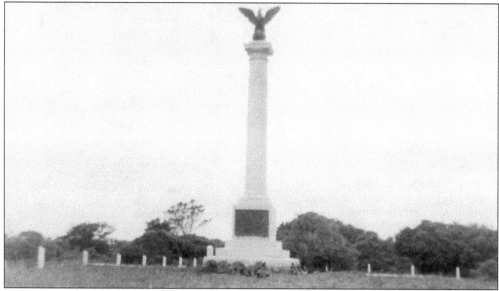

This monument is located at Fort Fisher in Battle Area. It was built by Greensboro architect Charles C. Johnson and dedicated on May 24, 1931. The United Daughters of the Confederacy and the Fort Fisher Memorial Committee, led by Annie Rogers Newell, raised money and obtained the site. This marker was relocated farther inland in 1948 to protect it from ocean erosion. (Mitsn Bartlett Mitchell.)

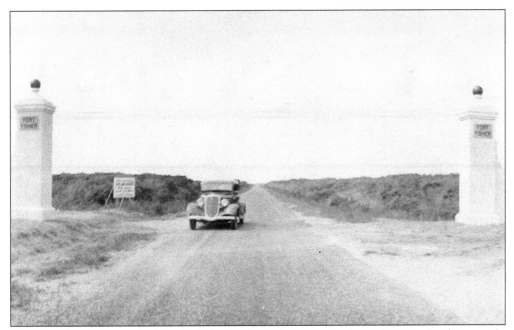

The car pictured is going north through the Fort Fisher gates in the early 1930s. Looking south, all one can see is barren land, maritime forest, sand, and mosquitoes. Jack Lewis, who lived close to the gates, said, "A busy afternoon in the '30s was watching 50 cars go by." Jack also remembered trucking up the road in a 1934 Plymouth at a big 35 miles per hour. (NHCPLNCR.)

This car is traveling south on Highway 421 in the early 1930s. It was reported that the first car to come through the gates had a blowout and scared everybody to death. The old tube was found by Crawford Lewis, who thought it was something one wears. He cut it in two, tied up the end, pulled it up his legs, and said they were good boots. (NHCPLNCR.)

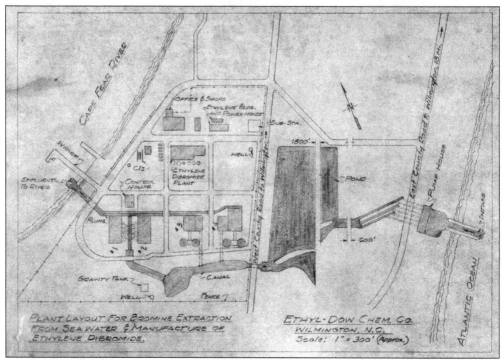

This picture shows the Ethyl Dow Chemical Co. plant's layout from the river to the ocean. They extracted bromine from seawater and manufactured ethylene dibromide, a "no-knock" compound used in gasoline and aviation fuel. They employed 250 workers at an annual payroll of $500,000. The facility cost $3.5 million and employed 1,500 construction workers. The plant operated from 1934 to 1946. (FPHPS.)

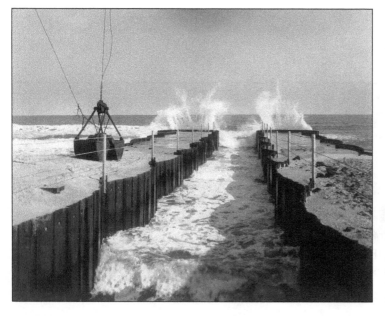

This 1930s photograph shows the Atlantic Ocean intake of Ethyl Dow. Seawater was pumped through a 200-foot intake pipe into a giant settling basin, 112 feet long, 76 feet wide, and 12 feet deep. It took 7.5 tons of ocean water to produce one pound of bromine. The plant processed 30 million gallons of seawater a day, yielding 16,000 pounds of ethylene dibromide. (FPHPS.)

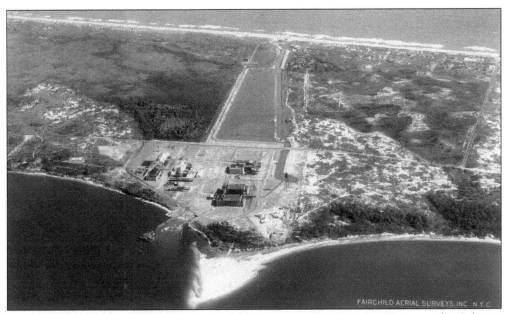

This 1930s aerial view of Ethel Dow is looking east from the Cape Fear River to the Atlantic Ocean. The property occupied 90 acres across the island. Construction included more than 3.5 million bricks and 38 miles of electrical wiring. The plant used 30 million kilowatt hours of electricity per year, causing Tidewater Power Company to link with Carolina Power and Light to supply the needs. (FPHPS.)

This picture is showing some of the machinery used at the Ethyl Dow Chemical Co. plant. An unidentified man is checking the gauges. Local legend states that on July 24, 1943, a German U-boat surfaced and fired artillery shells at Dow. None of the shells hit, and the U-boat, if it existed, disappeared. Some witnesses confirm that the plant shut down for two hours on that date. (FPHPS.)

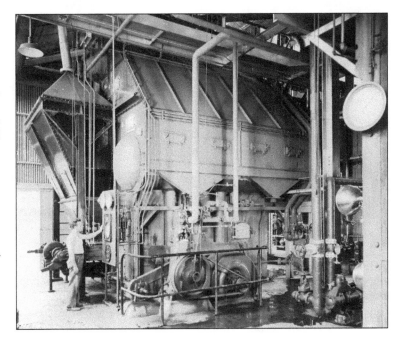

Pictured is the Flowers' home in the 1930s. John and Mae started coming to the beach in the 1920s and moved permanently in 1940. Their home was the first one built on unpaved Fifth Avenue. House was located at 111 South Fifth Avenue and has been elevated to two stories. He often climbed on top of the house to make sure the flag was okay. (Flowers family.)

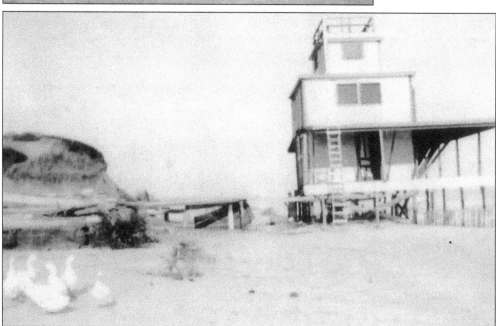

In 1921, Walter Winner built this house southeast of the monument at Fort Fisher. He operated a store and bathhouse on the bottom level known as "Walter's Place." During a nor'easter storm, two skeletons were exposed from the Civil War that had been buried underneath the house. The remains were included with the unidentified soldiers and buried at the monument. This picture was taken in the 1930s. (Jay Winner.)

Pictured from left to right are Charles Hewett, unidentified, and Walter Winner in the 1930s. Many stories have been told about fishing, but one of the strangest is the story of the capture of the sea bat, a manta ray. Walter said it was exact in its movements and that helped him catch it. The fish would swim toward shore and then back to sea. Walter and his companions stretched a net across its path, and the fish swam straight into it. The fish, as it was being loaded, tried to break away and pulled two motor boats with the motors running full speed in reverse. The battle lasted 10 hours. A 100-foot net and 100 feet of rope were used to bring the fish to shore. It was 15 feet, 9 inches across and 13 feet, 6 inches long. A small tail accounts for 6 feet, 2 inches of the length. The mouth was 34 inches wide and the eyes about 2 inches in diameter. Theodore Roosevelt is recorded as having harpooned a manta ray in 1916. (Jay Winner.)

This was the only building on the ocean side looking south from K Avenue in 1932. This house was owned by Mrs. Steen and was located near the present-day Admirals Quarters. (Kure family.)

Looking north from K Avenue, a few more houses are visible. This picture was taken in 1932 along what would eventually become Fort Fisher Boulevard. (Kure family.)

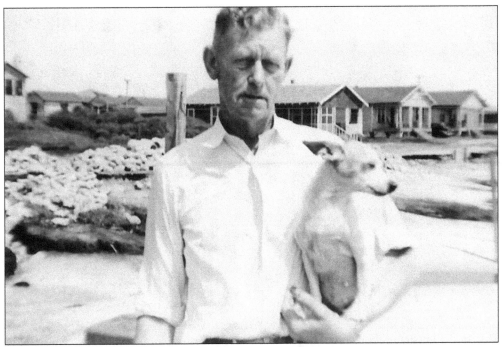

William L. "Cap" Kure is pictured with his faithful companion Baby Dog in the 1940s. The cottages in the background were located behind the present-day Jack Mackerel's Restaurant and went from the highway to the ocean. He rented the nine cottages for $23.50–$30 per week to tourists and fishermen. They were destroyed by Hurricane Hazel in 1954. He was married to Margaret Singletary. She had two daughters from a previous marriage, Mae Singletary Watters (Bud) and Elizabeth "Betty" Singletary Kure (Andrew). Betty was Punky Kure's mother, making Cap not only Punky's uncle but also his step-grandfather. Cap was born in 1881 and died in 1948. (Kure family.)

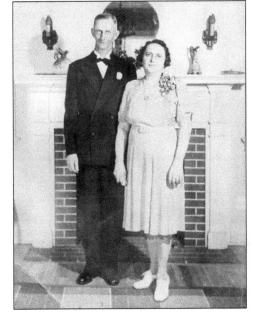

Lawrence and Jennie Kure pose for a wedding picture in 1933. In 1923, Lawrence built the first wooden fishing pier on the Atlantic coast. He was the vice-chairman and treasurer of the 1945 Progressive Association. This group paved the way for the incorporated of the town in 1947. He was a volunteer fireman and also served three terms as mayor. (Pat Robertson Rice.)

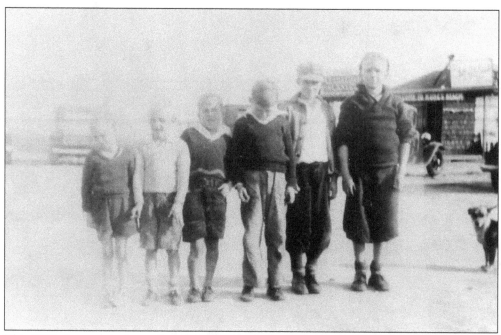

This 1935 photograph shows, from left to right, Robert Watters, Punky Kure, Hall Watters, J.L. "Son" Watters Jr., Nick Gore, and Vic Gore. In the background, one can see the pier and a Kure's Beach welcome sign. The dog's name was Bill. (Kure family.)

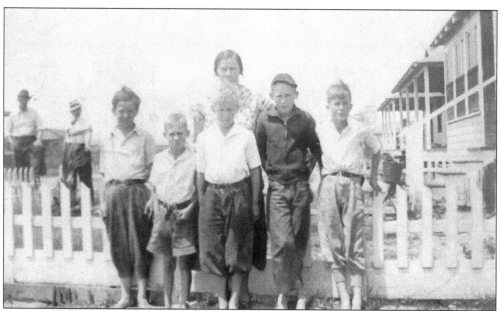

In the background are Cap Kure and Jim Smith. In the foreground are, from left to right, J.R. Hewett, Robert Watters, Punky Kure, Son Watters Jr., and Hall Watters. The lady watching over all these boys in 1936 is Mae Watters. (Kure family.)

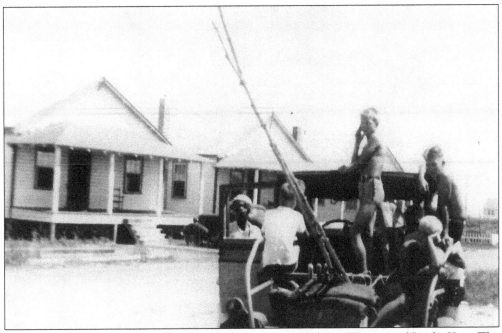

Pictured in 1936 are, from left to right, Bud, Robert, Hall, and Son Watters and Punky Kure. The Watters brothers were the sons of J.L. "Bud" and Mae Watters and were Punky's first cousins. Punky's mother and Mae were sisters. (Kure family.)

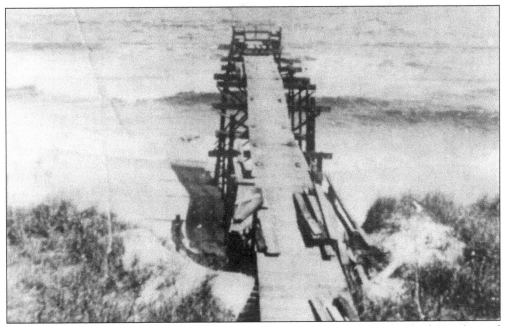

This private pier was built in 1936 by S.W. Flowers. The pier was built in front of his house, located between G and H Avenues, out into the Atlantic Ocean. (Kure family.)

Jennie Kure was the fourth daughter of Hans Adolph and Jennie Kure. Her earliest memories, in the 1920s, were of Grannie Kure and a large Atwater Kent cabinet radio: "Having a radio was exciting. We would go downstairs and listen to *Amos 'n' Andy* and those exciting Joe Louis fights. When school was out for the summer, we went to the Kure Cottage and stayed till Labor Day. We just walked out of the house jumped on the beach and went swimming. Women always wore wool stockings and bathing caps to go swimming; the men wore jerseys. We didn't have paved roads or telephones. A windmill pumped the water, and electricity came from a gas motor that ran a small dynamo. At night, the motor was started, and we had lights, but at 10:00 p.m. the lights went out and you used your kerosene lantern if you wanted to stay up. It was a quiet, small community where everyone knew everyone, and you didn't have to lock your doors." (Pat Robertson Rice.)

Edward Sandlin is pictured in the middle with unidentified friends on either side. Fishing was excellent that day in the late 1930s. Now, all those fish must be cleaned, which is the hard part, and only after that, the eating can start. (Nancy Faye Craig.)

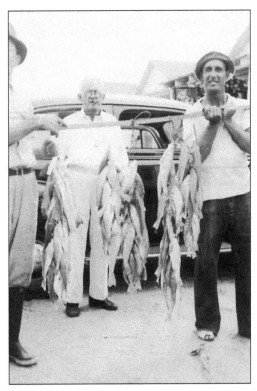

Edward L. Sandlin is enjoying his rocking chair on the front porch of his cottage. Sandlin's Tourist and Trailer Camp was located on the east side of North Fort Fisher Boulevard near the pier. Cottages ran from the highway to the ocean. He loved to fish and occasionally worked on the pier. He and his wife, Agnes, had four daughters and three sons. (Nancy Faye Craig.)

J. William H. Futchs Jr. and his wife, Eddie Sandlin Futchs, are seen enjoying the beach at the Sandlin Tourist Camp in 1937. Swimming, fishing, sunning, eating, and relaxing make for a happy day at the beach. William was born in 1902 and died in 1942 at the age of 40. Eddie was born in 1906 and died in 2004 at the age of 97. (Nancy Faye Craig.)

The Fort Fisher Pier was built by Walter Winner for Louis and Thomas Orrell in 1937. It was 1,000 feet long with a right L over the blockade runner *Modern Greece*. The pier housed a restaurant and a bait and tackle shop. Close by were 12 small cottages for the fishermen. Everything was completely destroyed by Hurricane Hazel in 1954. Only a few pier pilings remain standing. (FPHPS.)

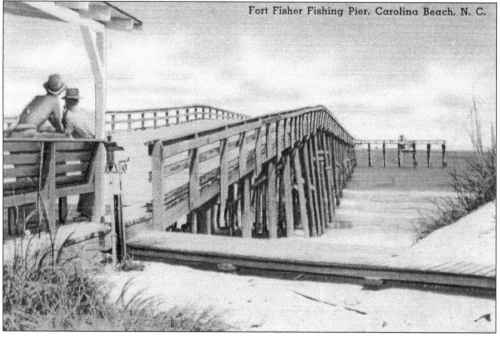

Fort Fisher Fishing Pier, Carolina Beach, N. C.

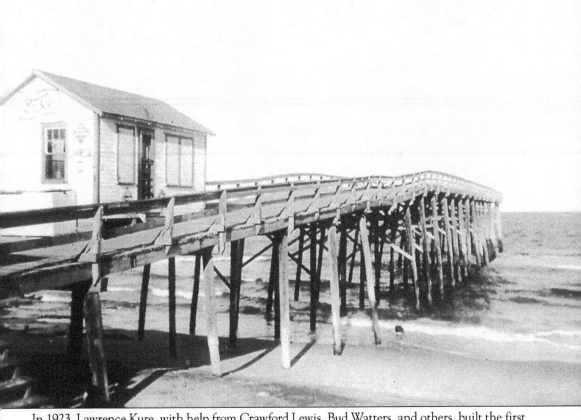

In 1923, Lawrence Kure, with help from Crawford Lewis, Bud Watters, and others, built the first wooden fishing pier on the Atlantic coast. The pier was built entirely of wood harvested from the river side of the peninsula. Precautions were not in place to protect the wooden pilings from the torpedo and limner worms, and in one year they literally ate away the supports and the pier collapsed. From his own designs, in 1924, Lawrence constructed a second pier. He developed what was later known as reinforced concrete pilings, which he used in the construction of this pier. Each post was 15 inches square and 35 feet long. They were moved to the pier site by rail dolly cars. The pilings were hand winched into place by Crawford Lewis and a helper. The pier was rebuilt 32 feet wide and 240 feet long. Pictured is the Kure Beach Pier in 1938. (FPHPS.)

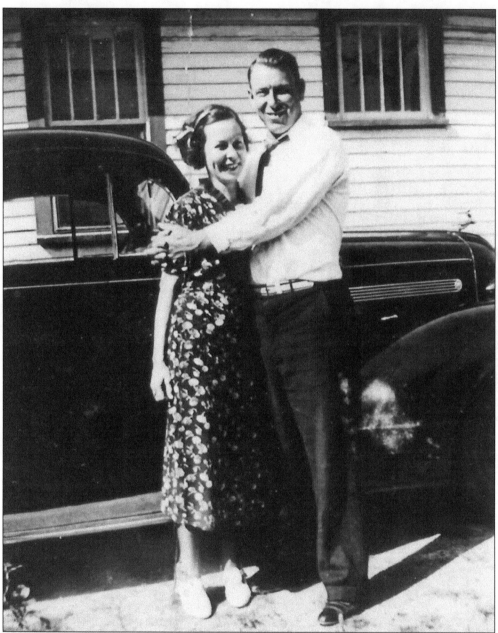

Gertie and James "Ed" Lewis are enjoying a hug at their home on the Cape Fear River in 1938. Nicknamed "Rocky," Ed was a local semiprofessional boxer from before the sport required wearing gloves. They had four children, Anna Lee "Sis," James "Brother," Isabell, and Judy. The home had a woodstove but no electricity until 1939. At night, the kids would catch lightning bugs, put them in a quart jar, set them on a table, and turn all the lamps out. In the morning, they would release their catch. Ed made his living taking people fishing. His route would take him past Zekes Island, Corncake Inlet, and High Rock, all in an 18-foot-long boat with no motor, only oars. Ed served three terms on council. Gertie served on the bylaws committee of the 1945 Progressive Association. Gertie was born in 1906 and died in 2000. Ed was born in 1904 and died in 1977. (Isabell Lewis Foushee.)

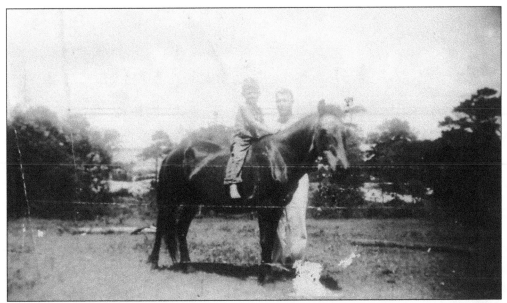

Pictured in 1939, Richard McDowell is hanging on to the pony's mane. Ed Lewis is standing by so no danger will come to Richard. The pony was a "marsh pony" from the North Carolina Outer Banks, and its name was Madge. Ed and Gertie Lewis kept the pony on their property at Fort Fisher. (Isabell Lewis Foushee.)

The Federal Point Methodist Church, pictured here, was constructed in 1917. Members and guests are enjoying an old-fashioned homecoming on the grounds in the late 1930s. The tract of land was originally deeded to Roger Moore in 1725. In 1736, Thomas Merrick obtained the land, and it was later sold to William Mosely. In 1794, the land was sold to Joseph Newton. (Davis family.)

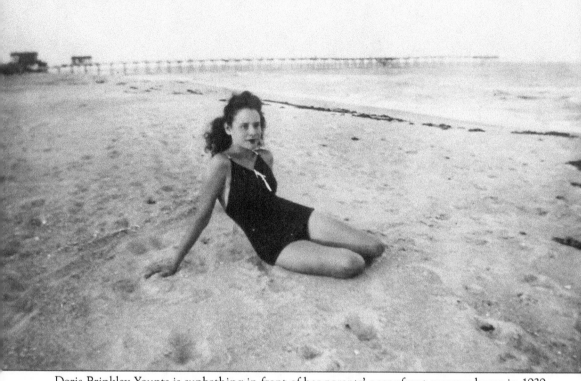

Doris Brinkley Younts is sunbathing in front of her parents' oceanfront summer home in 1939. Kure Beach Pier is in the background. Her father, Robert Ellis Brinkley, was a member of the 1945 Progressive Association. The family began coming to Kure Beach in the late 1920s. (Judy Younts.)

Four

KURE BEACH HISTORY
1940s

Nell Ford is standing in front of the open-air bowling alleys located on the south side of K Avenue. Jack Mackerel's now occupies a portion of that area. The building that housed the bowling alleys was enclosed and equipped as an emergency World War II first-aid shelter in August 1942. After the war, a grocery store and restaurant occupied this space. (Robert and Elizabeth Ford.)

Doris Brinkley Younts is posing on the railing of the Kure Beach Pier in 1940. Many young sweethearts carved their initials into these boards. (Judy Younts.)

John Webster Davis is seen standing beside his Chevrolet in the early 1940s. He had a truck farm on Davis Beach Road and also ran party boats for fishing. In the early 1900s, the Davises purchased land from L.C. Kure for 25¢ an acre for farmland and 5¢ for swampland. (Davis family.)

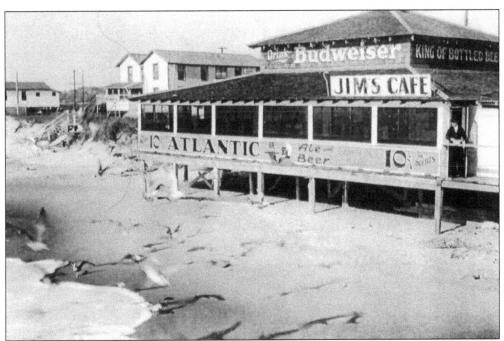

Jim's Café was built in 1940 by Cap and L.C. Kure. The oceanfront café, operated by Jim Stathis, was located south of the pier. L.C. Kure is pictured on the right feeding the seagulls. The café was destroyed by Hurricane Hazel in 1954. On the left are two rooming houses owned by the Kures. Jim was a member of the 1945 Progressive Association. (Kure family.)

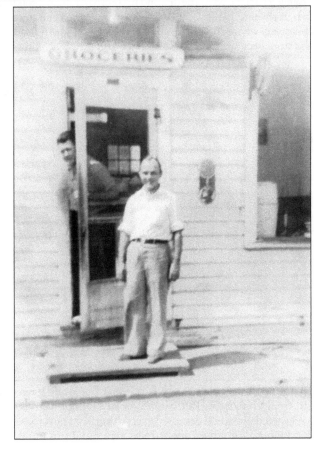

This 1940 picture shows, from left to right, unidentified and J. William H. Futchs Jr. He operated a grocery store on the southwest corner of K Avenue and Fort Fisher Boulevard. He was New Hanover County's first civilian defense casualty of World War II. William was fatally injured in 1942 while performing his duty as an air-raid warden during an official blackout. (Nancy Faye Craig.)

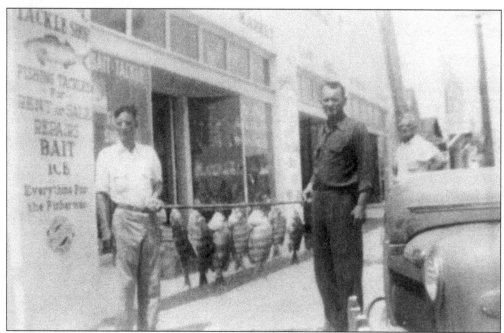

From left to right, Marvin Russ and his brother Taft are proudly displaying a huge catch of sheepshead fish in the late 1940s. Lew Weinberg, who owned the store, is on the extreme right. A portion of this store, where the tackle shop was located, now houses Freddie's Restaurant. The remains of the store became Smitty's Restaurant and is now a high-tech arcade. (Carolyn Russ Pole.)

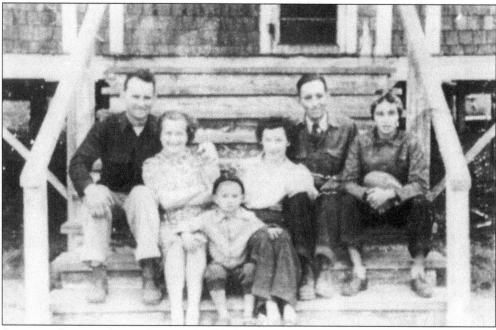

Sitting on the steps of a North Fort Fisher Boulevard house located beside Big Daddy's Restaurant are, from left to right, Taft, Shorty, Buddy, Lillian, Marvin, and Carolyn Russ in 1943. Shorty was a registered nurse and doctored everything from hurt toes to sore throats with kindness, patience, and humor. Taft served one term as mayor and two terms on council. (Carolyn Russ Pole.)

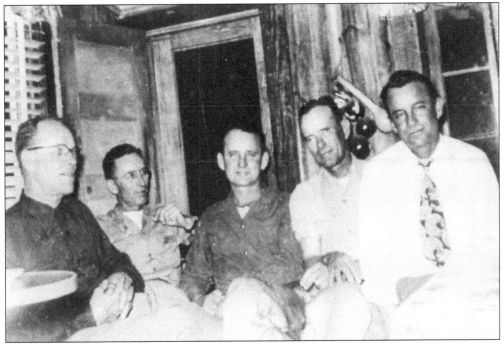

The Russ brothers, from left to right, Hardy, Marvin, Taft, N.H., and Monk, gathered for their annual fishing trip in the late 1940s. All the brothers except Taft worked for Carolina Power and Light. (Carolyn Russ Pole.)

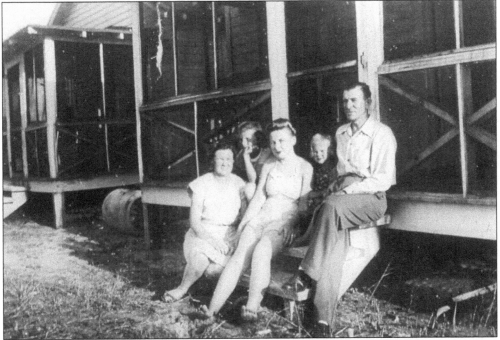

This 1946 photograph was taken on the steps of the Pier View Cottages, located on the south side of K Avenue between Fort Fisher Boulevard and Third Avenue. Posing are members of the Gobble family, from left to right, Mozelle, Jewell, Betty, Brenda, and Banks. (Jewell Gobble Nicholson.)

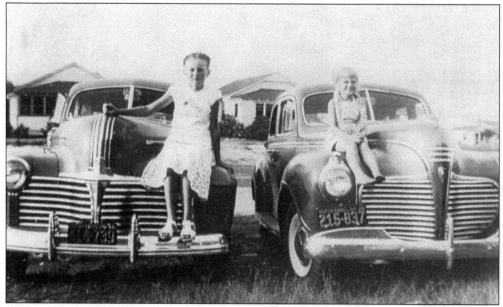

Looking north from the Pier View Cottages are Jewell Gobble, sitting on the hood of a 1941 Pontiac, and her sister Brenda, sitting on a 1941 Plymouth. The house on the left in the background was occupied by Calvin and Bonnie Fordham, and the one on the right belonged to the Clark family. (Jewell Gobble Nicholson.)

Andrew and Elizabeth "Betty" Singletary Kure Sr. are seen standing on the steps of their home on the north side of K Avenue between Fort Fisher Boulevard and Atlantic Avenue, in 1940. She was the daughter of Harry and Margaret Singletary and was born in 1907. Their son is Andrew E. "Punky" Kure Jr. Note the name of the house. (Kure family.)

In 1942, Fort Fisher was reactivated as an artillery antiaircraft training center along with Camp Davis in Holly Ridge. The primary range was at Fort Fisher. Between 1941 and 1944, at least 43 antiaircraft battalions trained here. Among those were the 54th Coast Artillery Regiment (the Army's only black 155-millimeter antiaircraft unit) and the Women's Airforce Service Pilots, WASP. (NCDCR.)

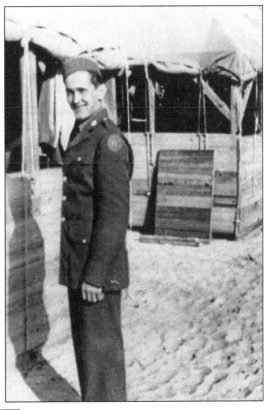

This unidentified soldier is standing in front of the wooden barracks at Fort Fisher. There were 316 tent frames, 48 frame buildings, a mess hall, outdoor theater, hospital, recreation hall, air strip, administration building, and three observation towers. After World War II, the barracks were sold for $175 each and became beach cottages. The buildings that remained were used briefly by the North Carolina Baptist Association in 1947 and 1948. (NCDCR.)

Four unidentified soldiers are standing in front of a wet, marshy section of Fort Fisher in 1941. One soldier said, "If nothing else hardened the men, at least the mosquitoes did. In the morning, the insects gathered in humming waves in the crowded latrines. It was a race to see who would win, the men shaving or the mosquitoes sucking them dry." (NCDCR.)

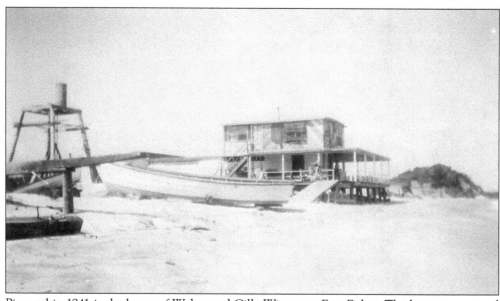

Pictured in 1941 is the home of Walter and Cille Winner at Fort Fisher. The home was moved twice, due to erosion, so wheels were put under it to make moving easier. In 1947–1948, it was moved to an oceanfront lot at F Avenue, and the first level was a store called "Walter's Place." The store closed in 1974. He served on council in 1954. (Jay Winner.)

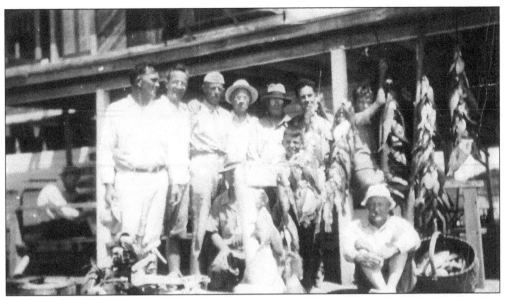

This Labor Day 1941 picture shows a successful day of fishing. Walter Winner is seated on the right. Note the unidentified man in uniform, third from the left. This photograph was taken only three months before Pearl Harbor. (Jay Winner.)

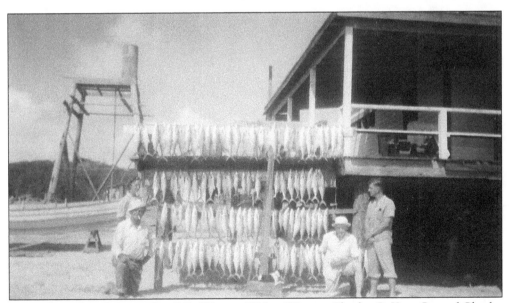

Pictured are, from left to right, Cille Winner, Walter Winner, Charles G. Yates Sr., and Charles Yates Jr. in 1941. A total catch of 112 mackerel weighing 238 pounds was caught in an hour and five minutes. It was good business for the Winners, and a grand day of fun for the Yateses. (Jay Winner.)

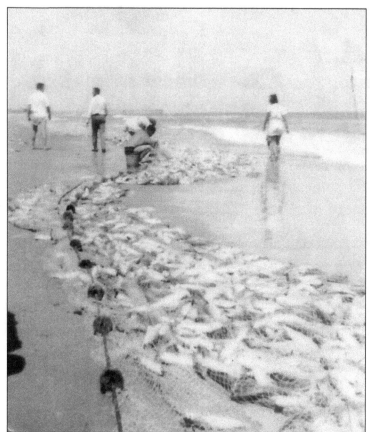

September 1941 yielded a huge catch of mullet. Picking the fish out of the net was exciting, but fishermen had to watch out for crabs. Some of the cleaned fish were put in barrels with salt and water and sealed. They were sent to stores inland and quickly bought. The fish were then soaked in freshwater and parboiled. Many people said they were delicious. (Jay Winner.)

This 1940s picture shows people pulling in a seine net. A seine is a net that hangs vertically in the water with weights at the bottom edge and cork floats at the top. It can be deployed from a boat or shore. Many times, the nets were ripped. Repairs were done with a net needle using a macramé knot. Net repairing is becoming a lost art. (Jay Winner.)

Mr. and Mrs. W.O. Ficklin, pictured in 1941, are on the steps of their home located on the west side of South Fort Fisher Boulevard near K Avenue, just south of the present-day Citgo station. She was a member of the 1945 Progressive Association and served as town clerk in 1959 when Stanley Cheek was mayor. (Mitsn Bartlett Mitchell.)

Mitsn Saunders, the first postmaster, petitioned for the establishment of a post office in 1940 and began her career in 1942. She had been a teacher and would correct any improper use of grammar when the children would pick up their parents' mail. She retired in 1961 after 19 years. She was much loved and respected. (Mitsn Bartlett Mitchell.)

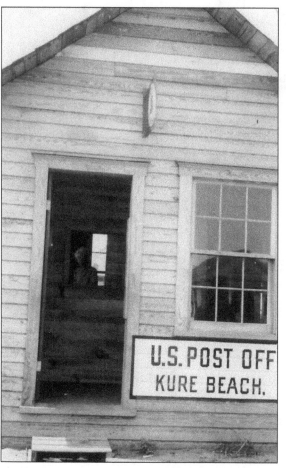

In 1942, the post office was located downtown on the south side of K Avenue, where today's Shirt Shack is, and was called Fort Fisher Post Office. The building was not heated, and Mitsn Saunders, the postmaster, stated, "Why, I've been here with two sacks on my feet. So I'm a fit subject for Siberia." She used an apple crate to sort mail. (Mitsn Bartlett Mitchell.)

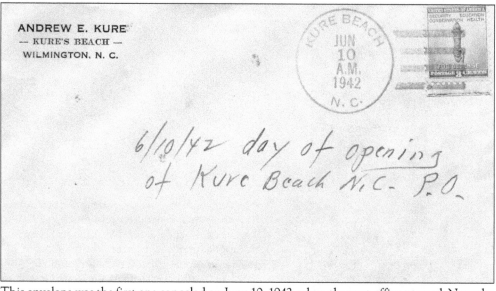

This envelope was the first one canceled on June 10, 1942, when the post office opened. Note the address of Kure's Beach, Wilmington, North Carolina, and a 3¢ stamp. (Kure family.)

Shirley Glasgow Jacobs Garnes began vacationing with her parents, John and Margaret; aunt and uncle Ethel and Billy Tilley; and cousins Ann and Billy at Kure Beach in the 1940s. While at the beach, they prepared their own meals and spent the days swimming, fishing, napping, eating, playing miniature golf, and looking at lifeguards. Shirley and her children, grandchildren, and great-grandchildren continue this vacation tradition. (Shirley Garnes.)

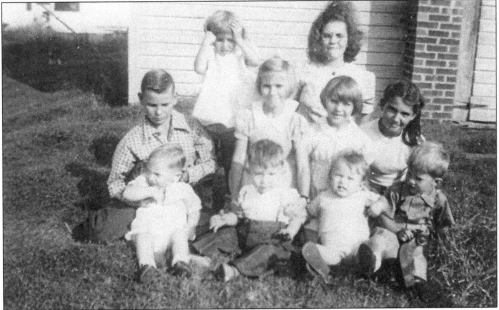

This 1942 Bible school was conducted in individual homes. Pictured from left to right are (first row) Bobby Ford, Tommy Ford, Harry Peters, and unidentified; (second row) James Gilmore, Cynthia Shier, Carolyn Shier, and Barbara Gilmore; (third row) Mitsn Bartlett and Josephine Gilmore. (Robert and Elizabeth Ford.)

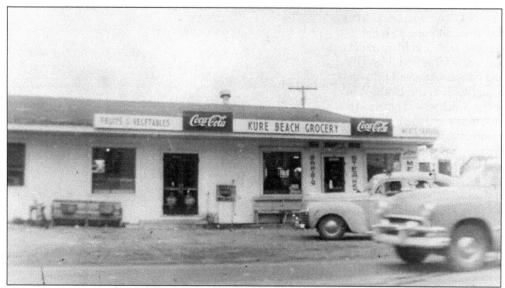

In 1943, Ed and Gertie Lewis purchased the grocery store on the southwest corner of K Avenue and Fort Fisher Boulevard. During the war, when meat was rationed, they would butcher one of their cows to sell. At 7:00 a.m., a line would be waiting. A restaurant and fish market were added later. They ran Lewis's Grocery until 1960. (Isabell Lewis Foushee.)

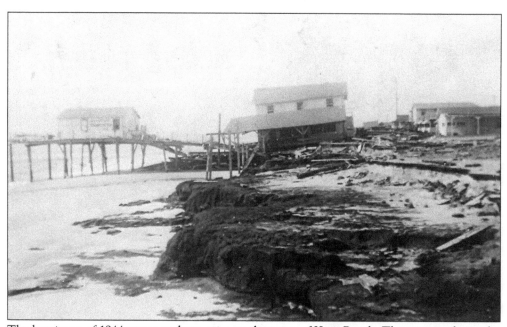

The hurricane of 1944 was very destructive to the town of Kure Beach. This picture shows the damage inflicted on the beachfront, exposing the hardpan and tree stumps beneath the sand. The building in the middle was partially destroyed, but a section was moved to the northeast corner of Atlantic and K Avenues. The pier also sustained damage. (Robert and Elizabeth Ford.)

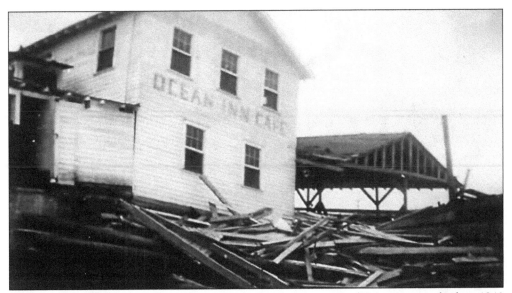

The Ocean Inn Café, located oceanfront on the southwest corner of K Avenue, was built in 1940 by L.C. Kure and was managed by George and Myrtle Stathis. Due to damage sustained by the unnamed 1944 hurricane, it was relocated to the northwest corner of Atlantic and K Avenues and renamed the "Four Winds." (Elaine Henson.)

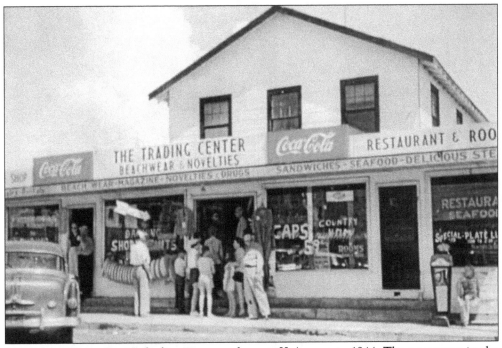

This is the Ocean Inn Café that was moved across K Avenue in 1944. The new name in the 1950s was the "Trading Center." The building housed the Fishing Hole Tackle Shop, run by Hoyle Brandon; a beachwear and novelties shop, run by Bill and Carole Lowder Cook; and a restaurant. The little girl sitting on the bench is Linda Kure Danner. (FPHPS.)

Pictured is the Bond house after the hurricane of 1944. This house was located on the oceanfront near H Avenue and Fort Fisher Boulevard. The cedar shakes on the house were delivered by the Kure train. By 1944, the house had changed hands and was owned by the Barnes family. (Coffey family.)

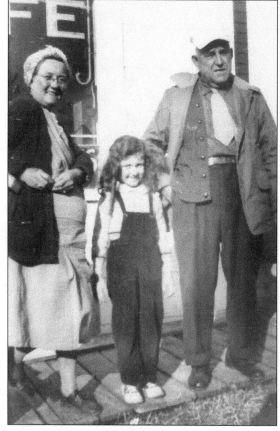

From left to right, Ada "Ma" Fry, Brenda Fry (Coffey), and Charles "Pa" Fry are waiting for a bus beside Canoutas's Café, located on the southeast corner of K Avenue and Fort Fisher Boulevard, in 1945. Note the wooden sidewalk. Ma was the recording secretary for the 1945 Progressive Association. (Coffey family.)

Lucille "Cille" Lane Sexton Winner, Joseph Walter "Jay" or "Cowboy" Winner, and Walter Winner are pictured at their home in 1945. In 1943, Jay, their only child, was born. Life was not always easy for Cille. Her first husband died in an automobile accident, leaving her with two sons. One fell from a tree and died at age nine, and the other son died at 56. (Jay Winner.)

Pictured is Pa Fry resting at the Rocks in 1945. This area in the late 1880s through the early 1900s boasted a hotel owned by Mrs. W.E. Mayo and the Hotel Fisher owned by Captain Harper. Small cottages, a restaurant, and fishing boats later appeared. The steamers *Passport*, *Louise*, and *Wilmington* brought tourists to the Rocks. All of these establishments were destroyed by storms. (Coffey family.)

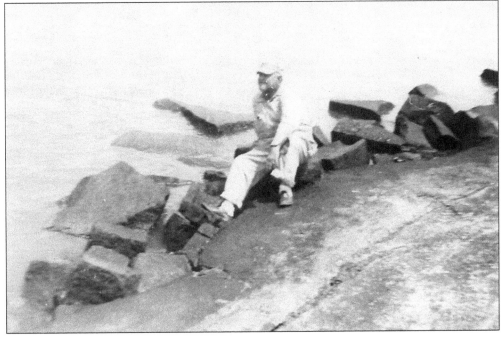

Pictured is Isabell Lewis in 1945 at age 15. She married Merritt Foushee in 1948 and had three sons, Tommy, Jack, and Jimmy. She was out of high school for 12 years before she returned to college and earned her bachelor's and master's degrees. Isabel then taught English at the University of North Carolina in Wilmington and was later vice chancellor. (Isabell Lewis Foushee.)

Andrew E. Kure Sr. is pictured on the left with unidentified friends in 1945. A horse-and-cart ride looks like fun. The house in the background was built in the 1930s and is located on North Fort Fisher Boulevard next to Big Daddy's Restaurant. (Kure family.)

Berta and Lew Weinberg, with unidentified friends, are outside their home on the northwest corner of K and Fourth Avenues. In 1945, he constructed a 60-by-80-foot building, estimated to cost $20,000. It included sandwich, tackle, gift shop, drugstore, bingo, and an area for dancing and parties. This was later Smitty's Restaurant. Currently, Freddie's Restaurant occupies the tackle shop portion, and the remainder is a high-tech arcade. (Robert and Elizabeth Ford.)

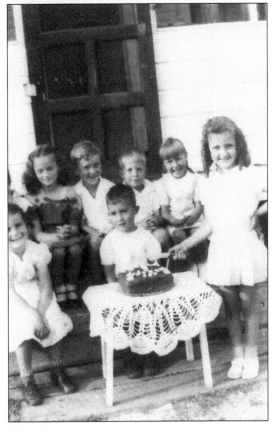

Brenda Fry, standing at right and about to cut her cake, is celebrating her fifth birthday with friends. Pictured from left to right are (first row) Barbara Mouring and Tommy Ford; (second row) unidentified, Doris Stathis, Bobby Ford, unidentified, and Mitsn Bartlett. The games included "Ring around the Rosy" and "London Bridge." The chocolate cake is homemade and served on a hand-crocheted table cover. The location is the northwest corner of Third and K Avenues. (Coffey family.)

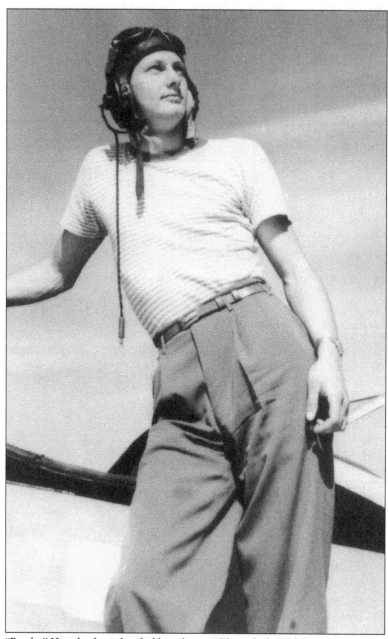

Andrew E. "Punky" Kure had just landed his plane at Bluenthal Field (now New Hanover County Airport) after doing low-winged acrobatics. He joined the Marines during World War II and used the GI bill to become a pilot. He is a 20-year veteran pilot with more than 30,000 flying hours as a commercial fish spotter. He is also an experienced scuba diver with over 100 hours underwater. He was one of the first divers on the sunken Civil War blockade runner *Modern Greece*. He said nothing could compare with seeing the bottom of the ocean from a plane. Seeing the many wrecks, the torpedo tears in the sides of ships, spotting lobster pots, and individual fish are all unbelievable sights. But the most beautiful sight is the sunrise. He served as Kure Beach fire chief for four years and served two terms on the council. He also served as a special police officer in 1955. (Kure family.)

Ada "Ma" and Charlie "Pa" Fry are in front of Fundy's Café, located on the south side of K Avenue, which is where a portion of Jack Mackerel's is now located. The Frys moved to Kure Beach from Lumberton in 1943. He and his son Therman "Fundy" Fry worked in the shipyard during the war years. Ma and Captain Charlie were retired from the railroad. (Coffey family.)

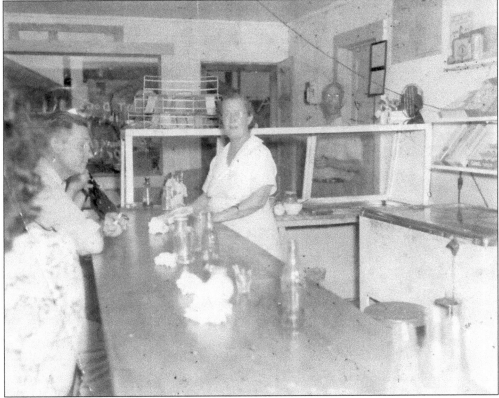

Ma Fry is behind the counter at Fundy's Café in 1946. The café was operated by Ma and Pa Fry along with their son Fundy Fry and daughter-in-law Mary Lee Tyler Fry. Isabel Lewis Foushee remembers eating delicious, hot hush puppies for the first time in Fundy's. In the background on the right is Linwood Flowers, who operated a grocery store beside the café. (Coffey family.)

Regular Dinner – 35¢	— Sandwiches —
	Bar=B-Q- 10¢
	Ham — 10¢
	Egg — 10¢
Ham & Eggs – 25¢	Tomato – 10¢
Bacon & Eggs – 25¢	Cheese – 10¢
Brains & Eggs – 25¢	Pimento – 10¢
	Chicken – 10¢
	Pickle – 10¢
Bar-B-Q- 25¢	Chicken Salad – 10¢
	Hamburger – 5¢
	Hot Dog – 5

Pictured is the menu for Fundy's Café. All the food was prepared fresh. Everyday specials consist of country-style steak, fried chicken, meatloaf, and all the fixings. Mary Lee Fry baked the delicious desserts, including chocolate, lemon, and fried apple pies and coconut, chocolate and pound cakes. All were made from scratch—no mixes here. (Coffey family.)

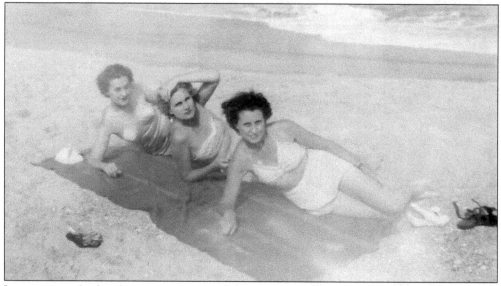

Lounging on the beach in 1946 are, from left to right, Vaughnie Sandlin Brown, friend Irene Lanier, and Eddie Sandlin Futchs. They are sunbathing on a wool Army blanket. Vaughnie, when she was not at the beach cottage, worked for the Atlantic Coast Line Railroad in Wilmington, and Eddie worked in the office of the Belk Berry Department Store in Wilmington. (Nancy Faye Craig.)

Pictured are Nathan "Mousie" and Gwen Bullard in the summer of 1946. He received his nickname by accident. He was a conductor for the Atlantic Coast Line Railroad and was looking under a chair for a lost object when a coworker saw him crawling around and said, "Here comes a mouse." This nickname stuck for a lifetime and became the name of their cottage. (Bullard family.)

Pictured is Brenda Fry with John O'Brien in 1947. The house on the left is where Big Daddy's is located. The O'Briens' home was located on the southeast corner of K and Fifth Avenue and featured a Koi pond, which fascinated the children. He was a member of the 1945 Progressive Association and a volunteer fireman and served one term on council. (Coffey family.)

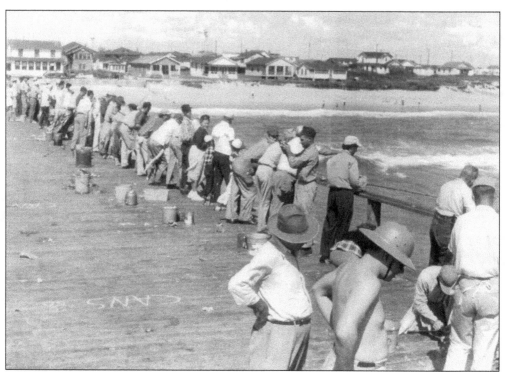

A crowded Kure Beach Pier is in the foreground. The water tower in the background on the left is at Ethyl Dow Chemical Co. plant off Dow Road at the Cape Fear River. The windmill on Third Avenue (where the community center is located) is visible on the right and was used for water. This picture was taken prior to 1947. (Kure family.)

This house, owned by Glenn and Marie Flowers in 1947, was located on Seventh Avenue. This land was later purchased by the federal government to be used as a buffer zone for the Army's Sunny Point Ocean Military Terminal. Their home was relocated to J Avenue between Fourth and Fifth Avenues and is still at that location. (Flowers family.)

These little boys have worked hard for their supper. From left to right, Billy Earp and Jay Winner are holding a string of delicious fish in 1947. (Jay Winner.)

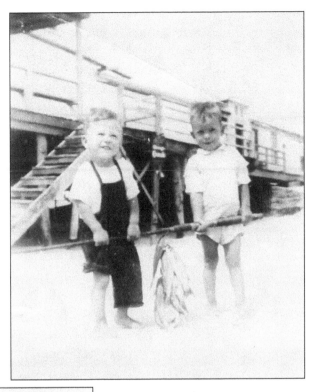

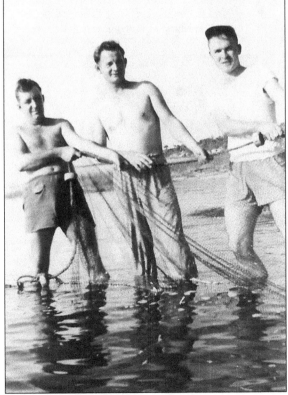

Pictured from left to right are Fundy Fry, unidentified, and Joe Inman in 1948. A half circle was made, and the net pulled to shore full of shrimp, fish, and crabs. No one ever thought of alligators being in the river, and no one ever saw one until years later. Fundy Fry served three terms on council, was a volunteer fireman, and served twice as fire chief. (Coffey family.)

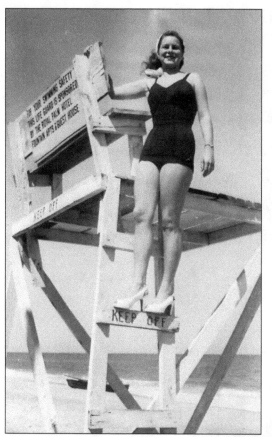

About 10,000 people were present in 1948 as Isabell Lewis, daughter of Ed and Gertie Lewis of Kure's Beach, was crowned queen at Carolina Beach's formal opening. Isabell is pictured on the lifeguard stand, in high heels, beside a sign that says, "Keep Off." Reigning beauties do have privileges. The prize was $50, which she used to buy her going-away outfit for her upcoming wedding. (Isabel Lewis Foushee.)

Pictured in 1948 at the Lutheran Church Bible School, from left to right are (first row) two unidentified, Tommy Ford, David Earl Church, and unidentified; (second row) Margaret Ford, unidentified, Bobby Ford, Linda Lilly, Brenda Fry, and Mrs. Davis; (third row) Carole Lowder Cook. Margaret Ford was a tireless worker at church and in Ford's grocery and fish market. Carole Lowder Cook's father, Marshal Lowder, was mayor in 1965. (Robert and Elizabeth Ford.)

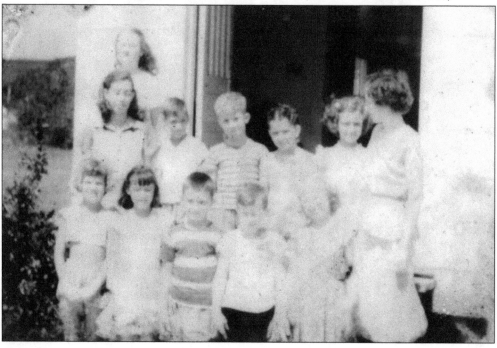

Pictured are Brenda Fry and brother Charles in 1948. The house was a converted barracks and had three bedrooms, bath, kitchen, and living room. The home had electricity, gas stove, kerosene heater, septic tank, and a well. Telephones were a party line, and there was no television until the mid-1950s. Milk was delivered to the house, and fresh vegetables were sold from a truck that made daily rounds. (Coffey family.)

Bobby Ford is getting ready to ride the Kure Beach Float in the second annual Azalea Festival in 1949. He has caught a scary looking sea creature! (Robert and Elizabeth Ford.)

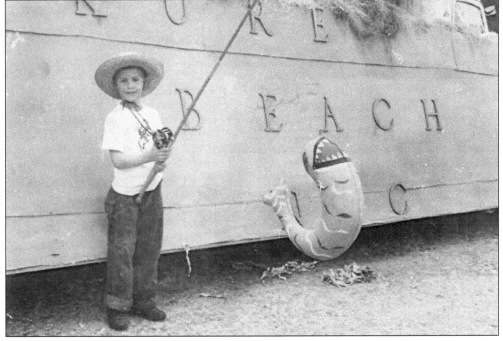

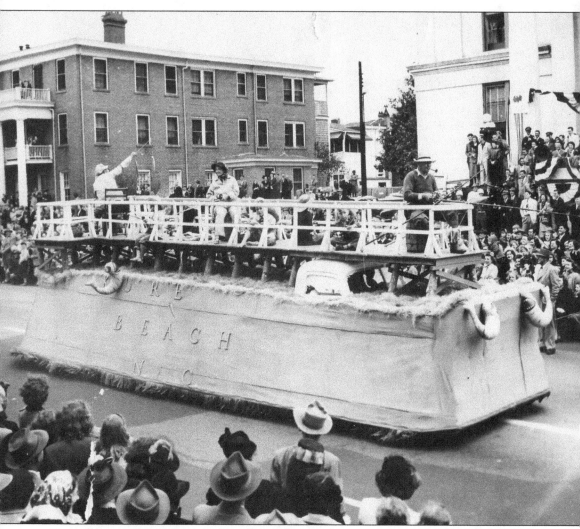

Pictured on April 3, 1949, is the Kure Beach float in the second annual Azalea Festival held in Wilmington. The parade was 20 blocks long and featured 36 floats. It took 50 minutes for the parade to pass by at any given point. The loudest-applauded float in the parade was the blue float with a replica of the Kure Beach fishing pier upon it. Pictured on the left of the float is Charles Fry, and in the middle is Ada Fry. This Azalea Festival had two queens. Martha Hyer, RKO movie starlet, was Queen Azalea II, and the other one was Hilda Burnett, who was beginning a Cinderella trip as part of the prize for being selected winner of the Mutual Broadcasting Systems "Queen for a Day." Mrs. Burnett, an English war bride, wished for an oil stove to heat the trailer home, which she resided in with her husband and small son. (Coffey family.)

Brenda Fry, Linda Lilly (Niedens), and baby Charles Fry are pictured in 1949 on unpaved Third Avenue looking north. The beach children always played outside. Downtown would be blocked off in the winter, and the kids played crack the whip on roller-skates that fastened to their shoes. Roller bat was played in the streets as well as hopscotch. (Coffey family.)

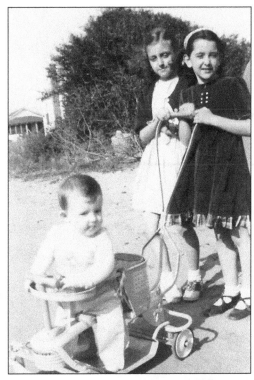

Pictured in 1949 are Lawrence Kure, standing, and Clarence Danner in the foreground. On the right is a corner of the Kure Beach Azalea Festival float. The sign is advertising John Flowers's barbershop, which was located behind Danner's fish market. The sign also advertised hot showers. This building is currently Bud and Joe's. Clarence served one term on council. (Robert and Elizabeth Ford.)

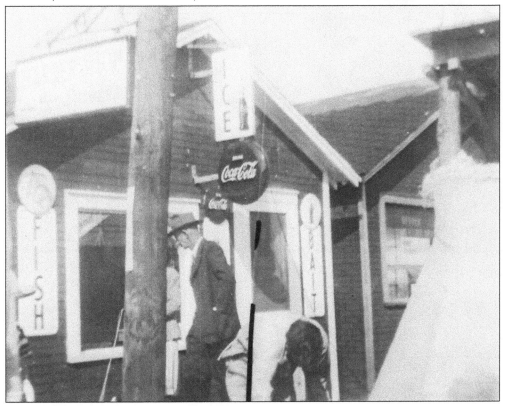

Pictured on unpaved Third Avenue is Brenda Fry on a bike in 1949. Beach children went to school at Carolina Beach for grades one through six. Grades seven through nine were at Sunset Park Junior High, and New Hanover High School for grades 10 through 12. The school bus ride to Wilmington was 55 minutes each way. (Coffey family.)

Mitsn Bartlett, on the left, and Barbara Mouring, on the right, are going to the beach for a day of fun, in 1949. Both girls and their families were permanent residents of Kure Beach. In the background is the Ocean Inn Café. (Mitsn Bartlett Mitchell.)

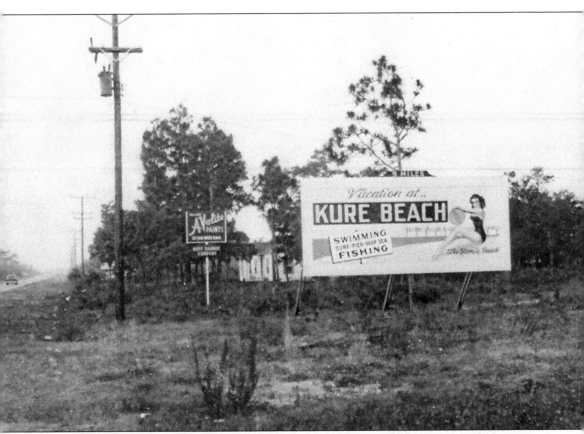

This billboard was located on the approach to Kure Beach off Dow Road from the late 1940s to the early 1950s. The house in the background was on Ninth Street, which is now part of the Sunny Point buffer zone. (Robert and Elizabeth Ford.)

The Kures pictured here in the late 1940s are (first row) Ann and Jennie (Lawrence's wife); (second row) Lawrence, Dorothy, Jennie, and Ellen. Dorothy was born in 1923 and died in 1973. Her husband was Maurice Parker Daniels. Dorothy and Maurice had two children, Susan and Linda. Jennie was born in 1917 and died in 2009. She was married to Bill Robertson and had three children: Pat, Toni, and Mike. Her second marriage was to Isham Trotter Bagley. Ellen was born in 1907 and died in 1990. Her husband was Rudolph Konig, and they had two children: Rudy and Peggy. Anne was born in 1915 and died in 1991. Her husband was James "Jim" Page, and they did not have children. Laura (not pictured) was born in 1913 and died in 1988. Her husband was William "Bill" Williford, and they had three children: Billy, Barbara, and Ellen. Note that the five girls were the children of Hans Adolph and Jennie Kure. Hans died in 1930, and Jennie and Lawrence, Hans Adolph's brother, married in 1933. (Kure family.)

Five

KURE BEACH HISTORY
1950s

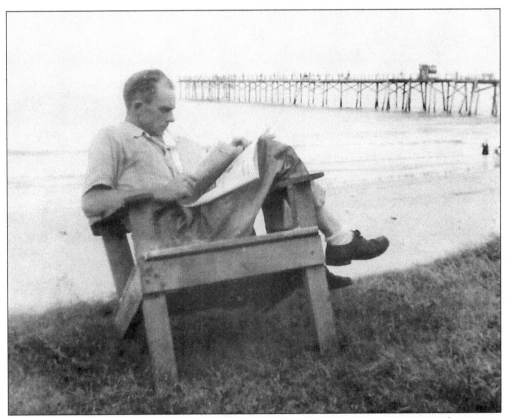

Pictured in 1950, Norman Parks is relaxing on the oceanfront with a newspaper and cigarette. The Kure Beach Pier is in the background. Norman owned a refrigeration and motor repair shop in Wilmington. (David Parks.)

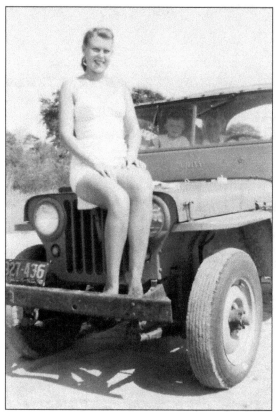

Mary Lee Tyler Fry is posing on the front of a World War II Army jeep in 1950. Her son Charles is looking out the windshield. Almost everyone owned an old jeep and would drive on the beach south of Fort Fisher. The strand was flat and wide with high sand dunes and great fishing. Many locals made extra money pulling out stuck vehicles. (Coffey family.)

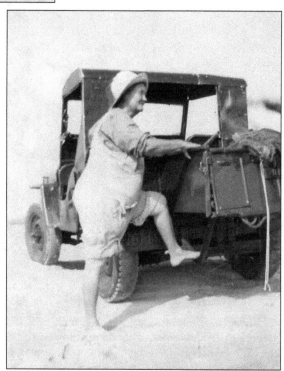

Ma Fry is pictured climbing into a jeep on the strand at Fort Fisher in 1950. She looks like she is ready to catch as many fish as possible. The fishing net is in the back of the jeep. (Coffey family.)

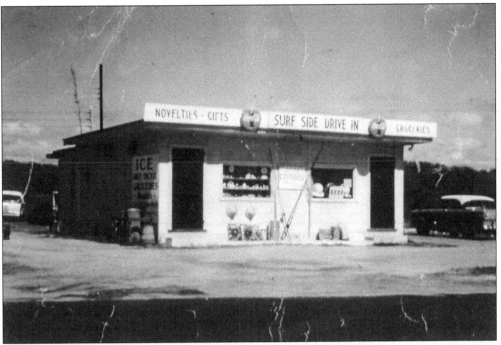

This store was owned and operated by Marvin Russ in the 1950s. The business was located on North Fort Fisher Boulevard and N Avenue. They sold sinkers, tackle, rods, reels, and anything a fisherman might need. (Carolyn Russ Pole.)

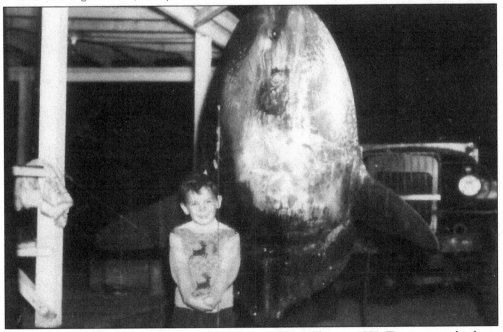

Jay Winner is posing with a mola mola (sunfish) at Walter's Place in 1950. Tourists saw this huge thing on the surface of the water and were scared. When Walter was informed, he got his boat and went to investigate. He netted the fish and brought it into shore. Locals and tourists soon heard about the strange creature and hurried to see what was happening. (Jay Winner.)

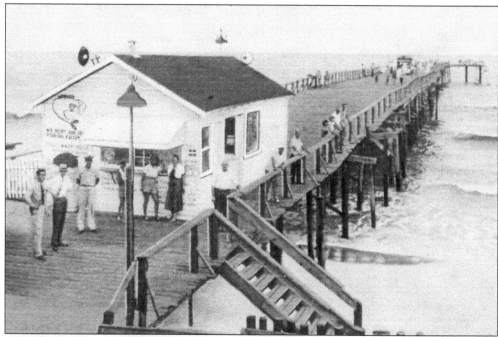

Pictured is a 1950 postcard of the Kure Beach Fishing Pier. Roasted peanuts were sold for 5¢ a bag at the ticket office. The following is written on the reverse side: "Come where you will meet your friends." Lawrence Kure is pictured on the left in the middle. (Elaine Henson.)

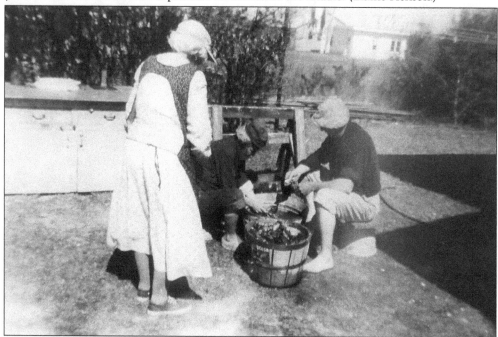

This early-1950s photograph shows, from left to right, Daisy Savage, Carey Woodcock, and Lemuel Bartlett washing mud off oysters for an oyster roast. Requirements for an oyster roast include a pit, wood, bricks, metal grate, wet burlap bags, and oysters. The oysters are ready to consume once they have opened slightly when steamed. (Mitsn Bartlett Mitchell.)

Lawrence and Jennie Kure built this home in the early 1950s. This was the largest brick house on the beach at that time. The house had a kitchen/dining room, living room, two bedrooms, one bath, and an attached garage. The house was located on the south side of K Avenue between Third and Fourth Avenues. The home was demolished in 2016. (Mike Robertson.)

Kure Memorial Lutheran Church was first visualized during World War II. Land was donated on North Third Avenue by Lawrence, Andrew, Dorothy, and Elene Kure in 1951. In the 1950s, a new church and parsonage was completed. "Serving the Savior by the sea" is the church's motto, and written over the door is "Pray without Ceasing." (Kure Memorial Lutheran Church.)

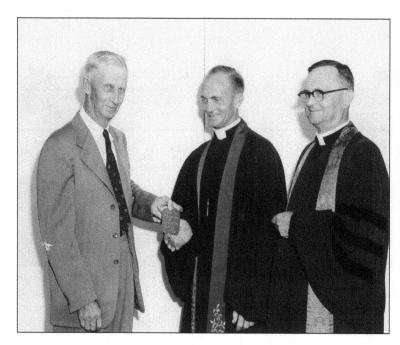

Pictured at the dedication of Kure Memorial Lutheran Church in 1951 are, from left to right, Lawrence C. Kure, Pastor David Johnson, and Dr. F.L. Conrad. Lawrence is handing the keys to the pastor. (Kure Memorial Lutheran Church.)

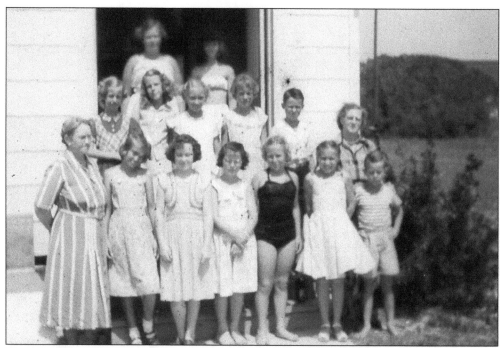

This picture was taken in front of the Lutheran church on North Third Avenue. From left to right are (first row) Mrs. O'Brien, Ellen Williford, unidentified, Barbara Mouring, Judy Lewis, Mitsn Bartlett, and unidentified; (second row) Barbara Williford, four unidentified people, and Mrs. Davis; (third row) and two unidentified people. (Kure Memorial Lutheran Church.)

Pictured are, from left to right, Bobby, Jimmy, and Tommy Ford in 1951. They are Bob and Margaret Ford's sons. Snow is rare at the beach, and no one can resist a snowball fight. The building in the background is a service station that was located on the corner of K Avenue and Fort Fisher Boulevard. The house is located beside Big Daddy's restaurant. (Robert and Elizabeth Ford.)

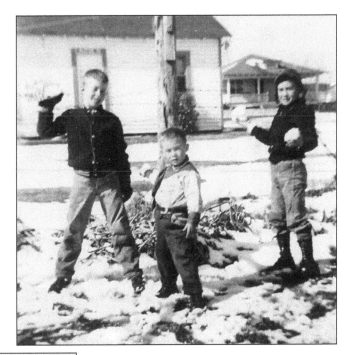

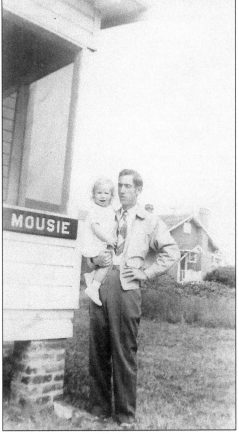

In 1951, Mousie Bullard is pictured holding daughter Debbie at their beach cottage. Houses at that time had no television, air-conditioning, or phones and had outside showers with cold water only. Everyone slept with their windows open and doors unlocked. Entertainment consisted of going to the beach, fishing, reading, or playing board games. The house in the background is the Williford house located at 305 K Avenue. (Bullard family.)

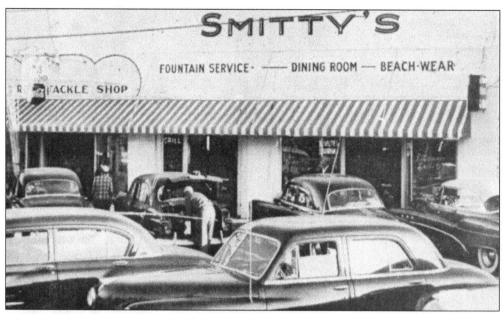

Smitty's Restaurant is shown in this postcard, dated 1962. The restaurant was opened in the early 1950s and was operated by Charles "Smitty" Smith. A small dance hall with jukebox was located down an alleyway beside the restaurant. All summer, the kids would dance, laugh, and hang out. A parent was always close to keep an eye on what was happening. Smitty served as mayor in 1973 and 1975. (Elaine Henson.)

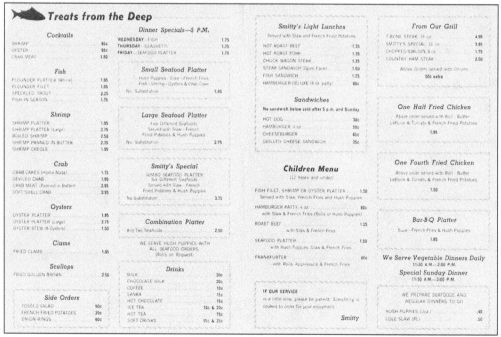

This appetizing menu is from Smitty's Restaurant in the 1960s. The seafood platter was $1.95, and a steak was $4.95. He also featured a treasure chest filled with wonderful jewels and toys. When the children finished their food, they were allowed to select a treasure from the chest. Many ate food they would not eat at home just to have a chance at the treasure chest. (Elaine Henson.)

Pictured from left to right are Andy Canoutas; an unidentified flight instructor from Fayetteville, North Carolina; and A.E. "Punky" Kure Jr. Spearfishing was a popular sport in the 1950s, and their aim must have been extremely accurate. Andy has been the Kure Beach Town attorney since 1963 and also was a temporary assistant police chief in 1953. (Kure family.)

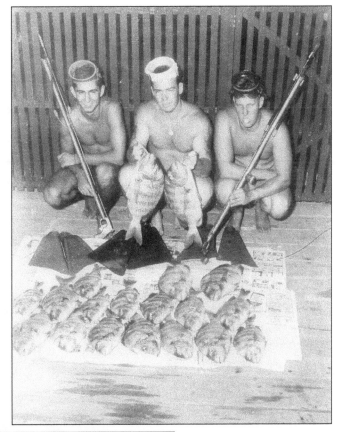

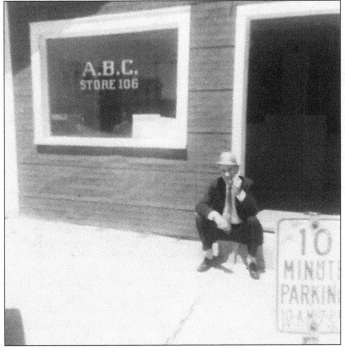

Pictured in front of the ABC store is Coy Little in the early 1950s. Permission to operate an ABC store was granted to the town in 1949. The town offices were located in the back of this building on the north side of K Avenue in the downtown area. The store closed in the mid-1960s. Bowman's Insurance now occupies this building. (Kure family.)

Pictured in the Heglar home, located on the west side of Fort Fisher Boulevard near F Avenue, are, from left to right, Jay Will "Dub" and Hazel Heglar with their friends Frances and Wilbur Davis Sr. (Davis family.)

Anne Ammenhauser Gibbs is enjoying the beach in the early 1950s. Walter and Thelma Ammenhauser, with their daughters Anne, Faye, and Jean A. Kure, moved to Kure Beach in the mid-1930s. He was associated with Tidewater Power and Light Company. The Ocean Inn Café is in the background on the right, and on the left is Smitty's Restaurant. (Kure family.)

Norman and Madie Parks are at the pier in the early 1950s. She was town clerk for eight years. He was the electrical inspector for the town and served two terms on council. From his home, he scheduled inspections and sold permits. She wrote the receipts and delivered the money to the town. He died in 1967, and in 1973 she remarried and changed her name to Genes. (David Parks.)

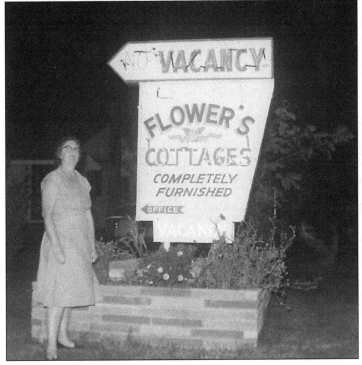

Pictured beside a sign advertising cottages for rent in the early 1950s is Mae Flowers. John and Mae's business card stated, "Pack your troubles and vacation here." He was the town barber, and his shop was located on the north side of K Avenue behind the present-day Bud and Joe's. John was a member of the 1945 Progressive Association. (Flowers family.)

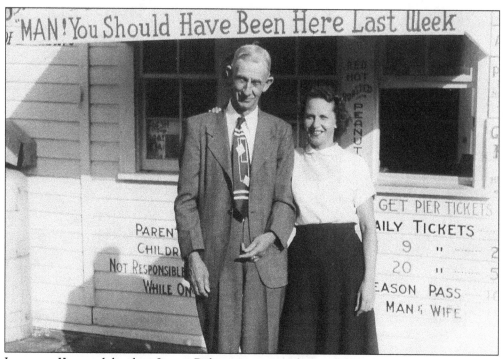

Lawrence Kure and daughter Jennie Robertson are standing in front of the pier ticket office in 1952. Everyone was familiar with the sign on the front of the ticket office; it said, "Man! You Should Have Been Here Last Week." The annual fishing-season pass was $10 or daily passes for 35¢ per day. In 1952, he sold his pier to J.H. "Bill" Robertson. (Mike Robertson.)

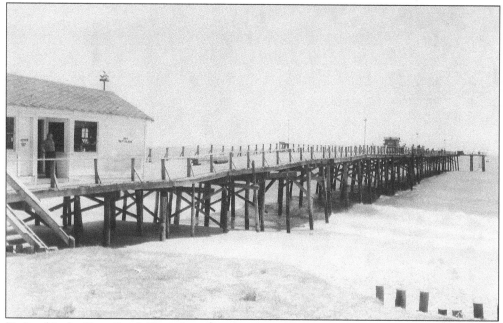

Pictured is the Kure Beach Pier after it was purchased by J.H. "Bill" Robertson from Lawrence Kure. The sign on the left says, "Private Keep Out," and the sign on the right says, "Get Bait In Side." (Mike Robertson.)

Bill Robertson was the owner of Kure Beach Pier from 1952 until 1984. He was an entrepreneur and recognized that the pier was under-advertised. For the next nine years, with a $20 typewriter and a used camera, he flooded the North Carolina newspapers and television and radio stations with stories and pictures of the glories of coastal fishing. He served two terms on council. (Mike Robertson.)

This view of Kure Beach in 1952 was taken by Punky Kure and Bill Robertson from the top of the Kure Beach water tower on Third Avenue, looking north. On the upper right side is Dow Chemical's ocean intake. The road to the right is Highway 421, and the unpaved road on left is North Third Avenue. (Kure family.)

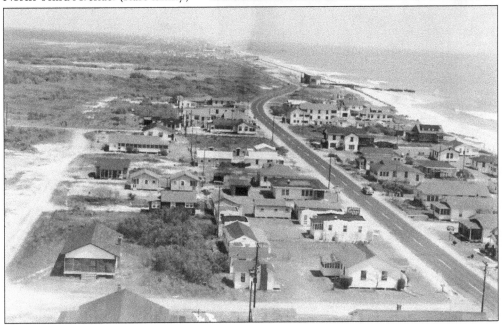

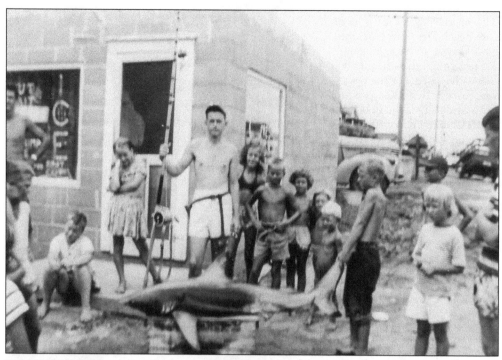

Merritt Foushee is showing off a shark that he had just caught. He is standing in front of the fish market he ran from 1950 to 1952. Standing on the left is Judy Lewis, on the right side is Buddy Russ, and in the back are the Fletcher children. Foushee was later assistant principal at Roland Grice and principal at Ogden and Pine Valley Schools. (Isabell Lewis Foushee.)

With pants' legs rolled up for fishing are, from left to right, Bessie Britt Tyler and Darius B. "Uncle Bun" Tyler. They are the maternal grandparents of author Brenda Fry Coffey. Uncle Bun's father, Pvt. James Tyler, was captured at the fall of Fort Fisher on January 15, 1865, and was sent to Elmira Prisoner of War Camp in Elmira, New York. (Coffey family.)

This 2¢ postcard was used to promote tourism at Kure Beach around 1952. The card was mailed in the spring so no one would forget to visit "The Family Beach" during the summer. (Robert and Elizabeth Ford.)

In 1953, Anne Kure was engaged to Jim Page. Note her engagement ring on display. Anne was the third daughter of Hans Adolph and Jennie Kure. (Pat Robertson Rice.)

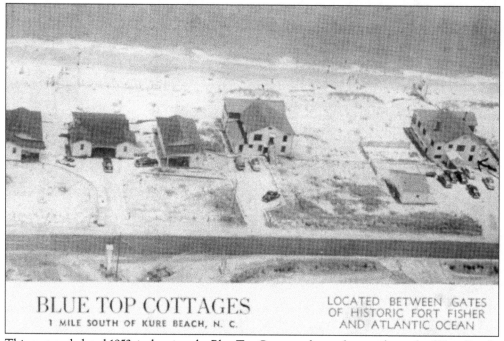

BLUE TOP COTTAGES

1 MILE SOUTH OF KURE BEACH, N. C.

LOCATED BETWEEN GATES
OF HISTORIC FORT FISHER
AND ATLANTIC OCEAN

This postcard, dated 1953, is showing the Blue Top Cottages, located one mile south of Kure Beach. The cottages were operated by Mrs. Guy L. Whicker, and its Carolina Beach telephone number was 2722. The cottages were completely furnished, except for bed linens. (Elaine Henson.)

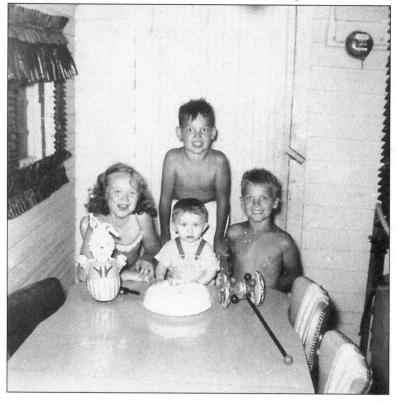

David Parks is celebrating his first birthday in 1953. He is pictured with his stepsister Carolyn Register, on the left; his stepbrother Butch Register, in the middle standing; and his stepbrother Chuck Register, on the right. The picture was taken in their home at Kure Beach. David and Chuck were lifeguards at Kure Beach in the late 1960s. (David Parks.)

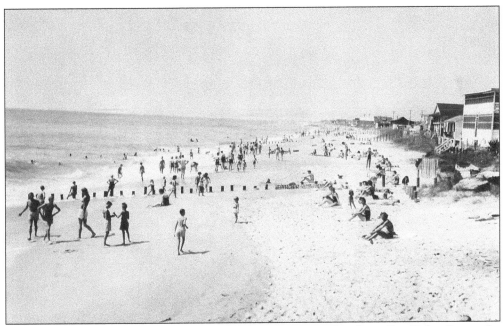

Looking south from the Kure Beach Pier in early 1953, one can barely see Fort Fisher Pier in the background. In the foreground seated on the sand is Jean Kure. The little girl at the edge of the water is Linda, Jean's daughter. (Mike Robertson.)

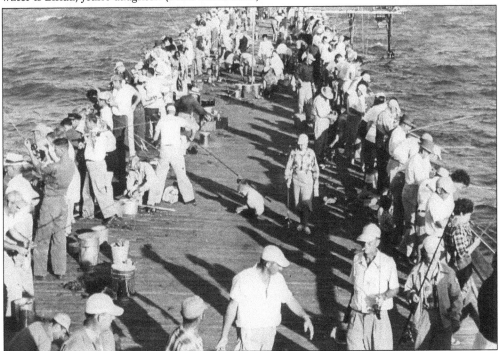

Here, people are shown fishing at Kure Beach Pier in the fall of 1953. Note the boat docked under the L on right side of picture. There were vertical steps used by fishermen to climb down and board the docked boat. Then, the fishermen were carried out to a larger fishing boat anchored farther offshore to continue their fishing adventure in deeper waters. (Mike Robertson.)

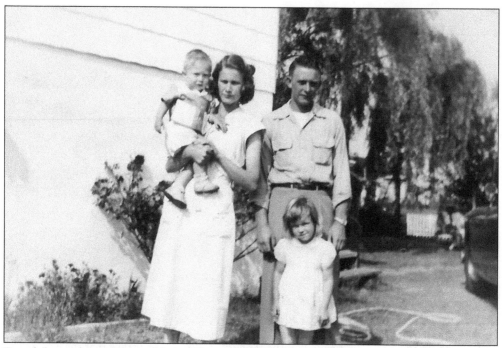

From left to right are Johnny, Marie, Glenn, and Linda Flowers in 1953. During his fishing career, which spanned 30 years, Glenn ran boats from the Carolina Beach marina and the bay at Fort Fisher. One of his boats was named the *Linda Marie*. Marie ran "the Shack" at the Rocks and sold soft drinks, candy, and rented fishing rods. (Flowers family.)

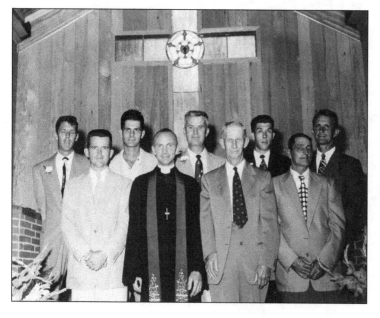

This picture was taken inside Kure Memorial Lutheran Church in 1954. Pictured from left to right are (first row) Merrit Foushee, Rev. David Johnson, Lawrence Kure, and Fred Schenk; (second row) Oscar Wrenn, Jason Lentz, Bob Ford, Bob Hooker, and Bill Williford. Jason Lentz served as fire chief in 1960. Oscar Wrenn served one term on council. (Courtesy Kure Memorial Lutheran Church.)

Here, beach girls are just hanging out and having fun in 1953. From left to right are Mitsn Bartlett, Dottie Piner, unidentified, and Joyce Piner. The two houses in the background are the "Cap" Kure cottages, in the right foreground is the Ocean Inn Café, and to the left is Smitty's Restaurant. The Kure Beach water tower is visible in the distance. (Mitsn Bartlett Mitchell.)

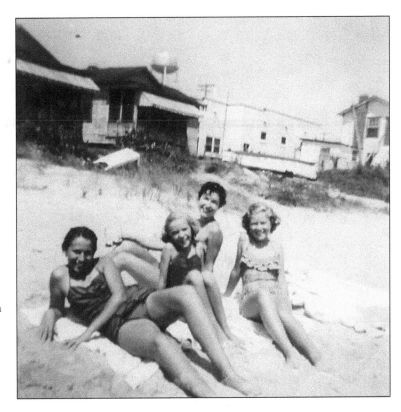

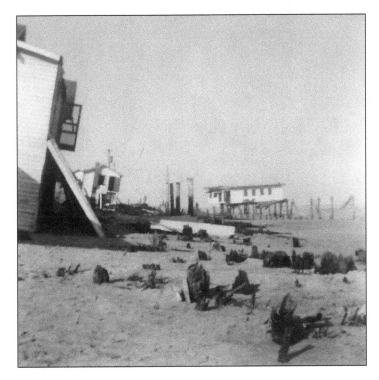

Hurricane Hazel, in 1954, caused extensive damage on the oceanfront. The storm destroyed many homes and businesses and also uncovered the hardpan and tree stumps on the beach, which is now covered with sand from beach renourishment. (David Parks.)

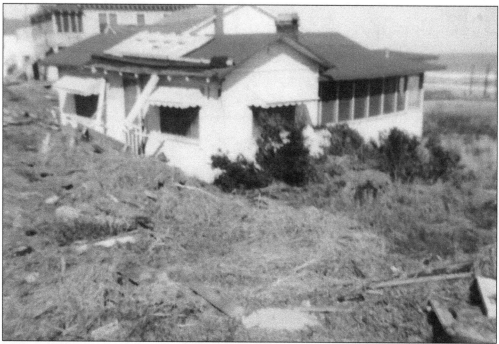

Hurricane Hazel hit the coastline on October 15, 1954. This home, located oceanfront at E Avenue, is one of many that were damaged by the storm. (Jay Winner.)

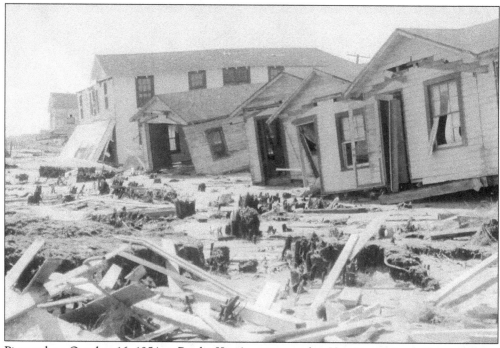

Pictured on October 16, 1954, is Punky Kure's property after Hurricane Hazel. Cottages were located south of the pier on the oceanfront. Note the tree stumps on the beach and hardpan. (Mike Robertson.)

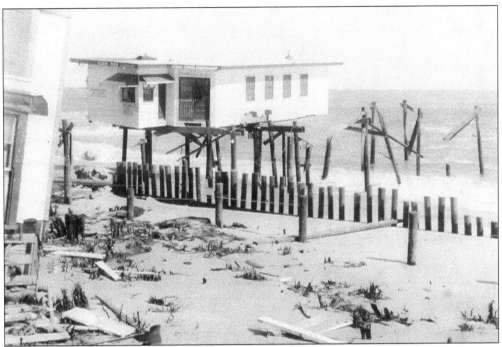

The pier house was all that survived after Hurricane Hazel's visit in October 1954. Bill Robertson, owner of Kure Beach Pier, was among the few people that believed the hurricane would be devastating to the beach. He was able to remove some items from the pier house, but there was no way to secure the pier. (Mike Robertson.)

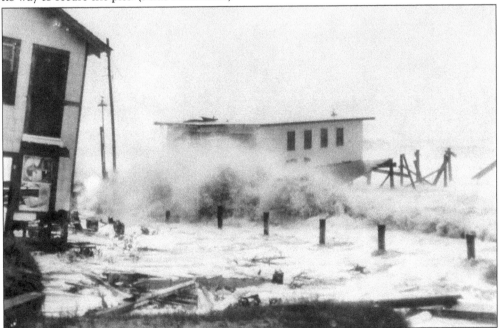

The pier is gone, but the restaurant and tackle shop are hanging on. The building on the left is the Ocean Inn Café. This picture was made before Hurricane Hazel had made landfall. (Mike Robertson.)

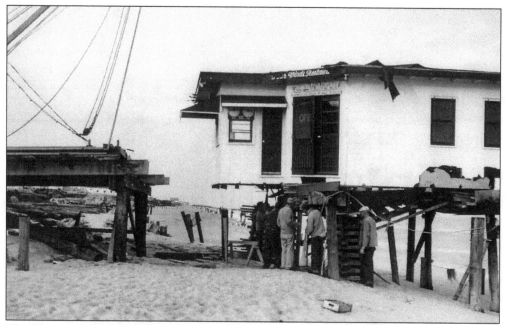

The Hurricane Hazel–damaged pier house is in the process of being moved to the southeast corner of K Avenue, oceanfront, to become the present-day Kure Beach Diner. The sign on the damaged building says, "Four Winds Restaurant: Famous for Fine Food." (Mike Robertson.)

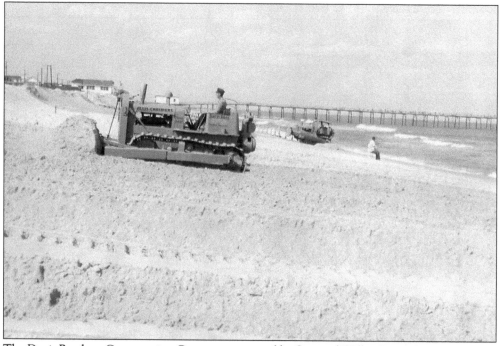

The Davis Brothers Construction Company, operated by Otis and Wilbur Davis Sr., are restoring the sand dunes at Kure Beach after Hurricane Hazel in 1954. Otis is pictured on the tractor in the foreground, and Wilbur is on the tractor in the background. (Mike Robertson.)

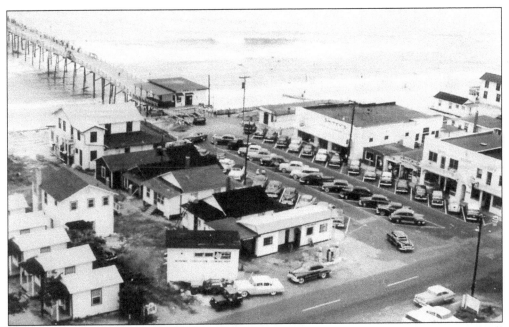

This 1953 photograph taken from the water tower shows Kure Beach. On the left are small cottages operated by U.S. Church. The two-story house was the home of Punky and Jean Kure. On the left oceanfront is the Trading Post, and next to it are two World War II barracks, which now house Bowman's Insurance and Bud and Joe's. The two houses were owned by the Kures. (Kure family.)

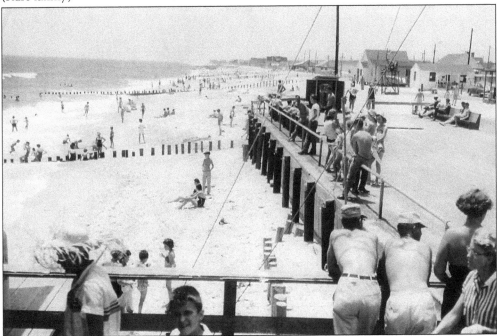

The bulkhead on the right was built in 1955 and featured a dance floor and jukebox. It was a social hangout for teenagers and adults. Looking south, the jetties, which were used to halt erosion, are visible. (Mike Robertson.)

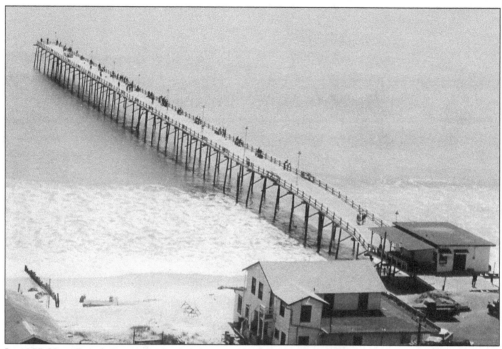

In 1955, Kure Beach Pier was 880 feet long, making it the longest pier over water on the Atlantic coast. A quarter of a million fishermen and spectators see 61 varieties of fish caught here annually. (Mike Robertson.)

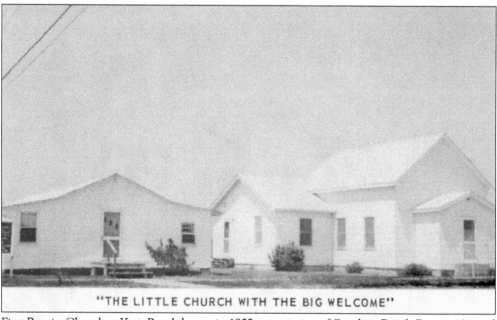

"THE LITTLE CHURCH WITH THE BIG WELCOME"

First Baptist Church at Kure Beach began in 1955 as a mission of Carolina Beach Baptist. A total of 14 lots were purchased for $9,490 on Sixth Avenue. The first services were conducted in an Army barrack, pictured on the left, which had been remodeled. On the right is the Old Federal Point Methodist Church that was purchased for $200 from the federal government. (First Baptist Church Kure Beach.)

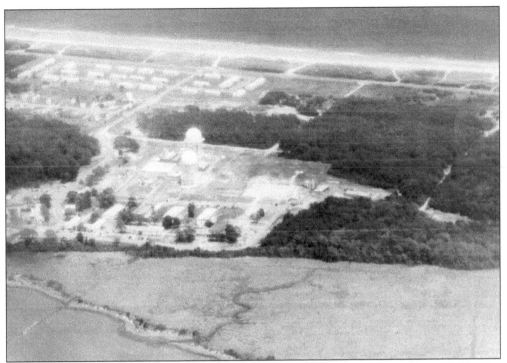

This 1950s aerial view is of the 701st Air Force Radar Squadron Base at Fort Fisher. The facility opened in 1955 and was deactivated in 1988. The Air Force retained the housing complex and converted it into the Fort Fisher Air Force Recreation Area. No houses or condominiums were on the oceanfront at that time. (Kure family.)

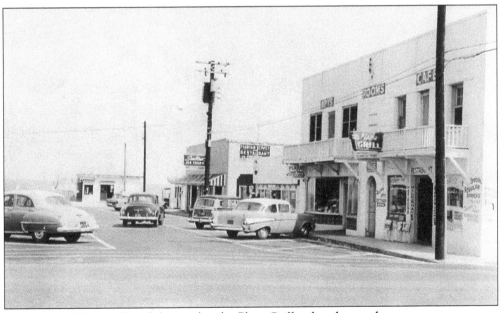

Pictured in 1956 are, from left to right, the Plaza Grill, a beachware shop, grocery store, post office, Smitty's Restaurant, and the Ocean View Grill (now Kure Beach Diner). Note the phone booth on the ocean-side corner. (Mike Robertson.)

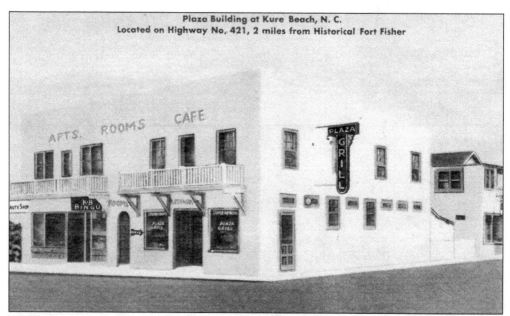

This 1957 postcard shows the Plaza Grill, owned by George and Lola Canoutas. The postcard states, "Famous for seafood, steaks and chops. Make this your headquarters when at Kure Beach. Comfortable rooms and apartments. Hot and cold showers. Private baths." They offered dinners for 75¢ to $1.99, including chicken 'n basket, hamburgers, and hot dogs. George served one term as mayor and six terms on council. (Elaine Henson.)

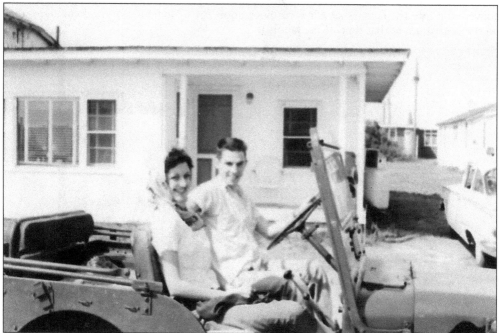

Riding in an old military jeep with no seat belts or roll bars was an everyday occurrence for Dan and Brenda Coffey. Taking friends for a ride was always an adventure, especially when going up one side of Sugar Loaf and straight down the other side. The only thing one could see was sky and then the river. Screams were heard for miles. (Coffey family.)

Here, in 1958, four-year-old Mike Robertson is leaving Kure Beach Pier after fishing with his faithful dog Buttons. Mike is carrying the catch of the day and is ready for food and a nap. In the background is a sign for Lowder's Tackle Shop. Mike has owned the pier since 1984. (Mike Robertson.)

This 3¢ postcard was used to promote fall fishing beginning in 1958. It states, "It is that time of year . . . We are expecting you!" (Robert and Elizabeth Ford.)

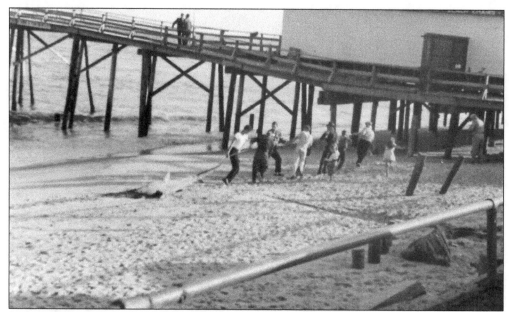

A shark is being landed on the beach beside the pier in the mid-1950s. Shark fishing was a sport many enjoyed. The battle could take hours, depending on the size. Word would spread that a shark had been hooked, and breakfast, lunches, or dinners would be left uneaten to go watch the battle between man and beast. (Isabell Lewis Foushee.)

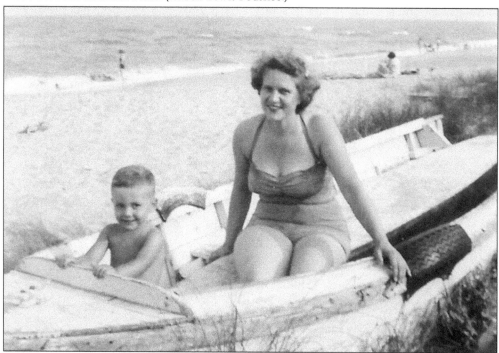

Gary Teague and his mother, Faye, are pictured enjoying a day at the beach in July 1954. Gary is pretending to be the captain of the ship. Faye was postmaster in the early 1970s and was the only person that worked in the post office. There was no delivery service during her tenure. Gary was appointed postmaster in 1999. (Gary Teague.)

Six

KURE BEACH HISTORY
1960–2000

Bobby Ford is managing the Ford's grocery store, located on the southwest corner of K Avenue and Fort Fisher Boulevard, in 1962. He attended college for two years and then returned home to help run his family's store for two years. He continued to come home on weekends while completing his college degree. He taught math for 30 years before retiring from the Wake Forest school system. (Robert and Elizabeth Ford.)

This picture, taken in 1960, is looking northeast and was taken in the backyard of the Bullards' home at 110 South Third Avenue. Pier View Cottages, owned at that time by Mr. and Mrs. Scarborough, are pictured in the background. Pictured from left to right are Nathan "Mousie" Bullard, Deborah "Debbie" Bullard (Britt), Cathy Bullard (Ditto), Nancy Bullard (Biggerstaff), and Gwen O'Neal Bulllard (standing). (Bullard family.)

Pictured are Postmaster Mildred Bartlett and Larry Willoughby at the ribbon-cutting ceremony opening the new Kure Beach Post Office on Fort Fisher Boulevard. Her career began in 1945 as assistant postmaster. She became acting postmaster in 1961 and was appointed postmaster in 1962. She served 27 years. In 1957, she was paid $1.69 per hour. This building was originally the Bank of America. (Mitsn Bartlett Mitchell.)

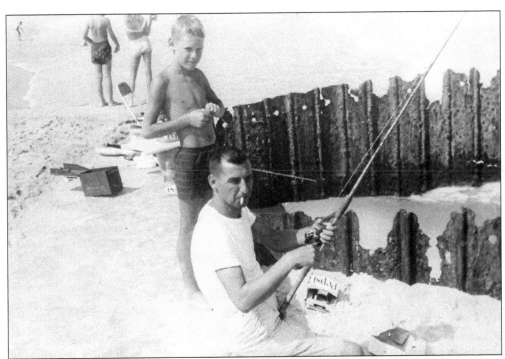

Father and son, Irvin and Bubba Rivenbark, are fishing at the old Dow Chemical ocean intake in 1962. The fishing tackle box on the left is an old military ammunition container, and they are using spark plugs for sinkers. A picnic had already occurred with Pepsi-Colas and hot dogs from Paul's Place. The children in the background are Janet Rivenbark (Straul) and Windy Thompson. (Bubba Atkinson.)

Pictured in front of the Atlantic Surf Shop located at G Avenue and Fort Fisher Boulevard are Clarence "Sonny" and Linda Kure Danner. In the early 1960s, Sonny and Herman Pritchard founded one of the first surfboard manufacturing companies on the East Coast. "DAN PRI" started by ordering two surfboard kits from California. They were assembled and sold immediately for around $110 each. They were produced until 1973. (Kure family.)

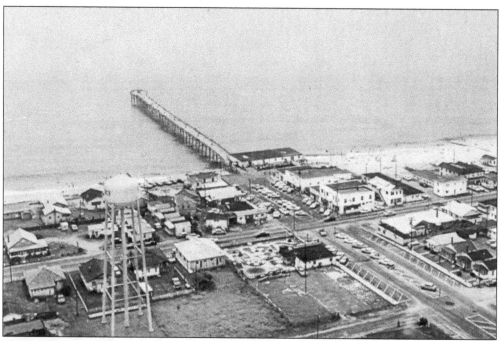

This 1960s postcard is showing the business section of the town. Pictured in the center is the miniature golf course at Big Daddy's. (Elaine Henson.)

Bobby Ford, on the left, with his father, Bob, are inside their grocery store in 1975. They operated a fish market, tackle shop, and grocery store on the southwest corner of K Avenue and Fort Fisher Boulevard from the 1960s to 1980s. Bob was a member of the 1945 Progressive Association, served as acting town clerk in 1958, and served one term on council. (Robert and Elizabeth Ford.)

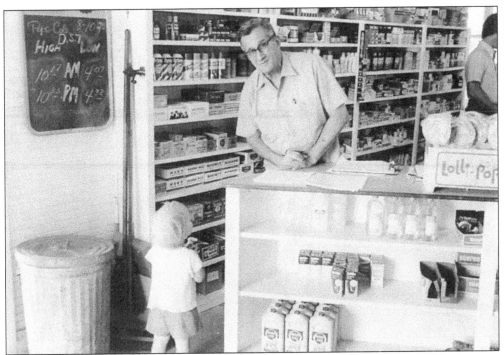

Bill Williford is pictured behind the counter of Ford's grocery store in 1975. His little customer is Chris Ford, son of Bobby and Liz Ford. Chris is negotiating for an ice cream popsicle. Bill served eight terms on the council. (Robert and Elizabeth Ford.)

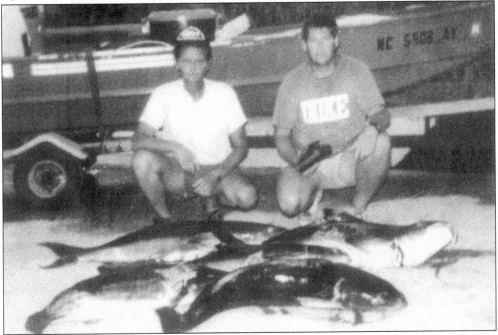

Bill Nelson, on the left, and Bubba Atkinson, on the right, are proudly posing with their catch of five cobia caught at High Rock in 1985. They were using a johnboat and a trash can for the huge, live popeye mullet used for bait. The fish weighed from 30 to 46 pounds each. (Bubba Atkinson.)

Bubba Rivenbark's son Jamie Ray is resting on his skim board in 1987 beside the jetties at H Avenue. Running in the surf and jumping on this small board requires agility and balance. Falling is to be expected, but when successful, the ride is wonderful. (Bubba Atkinson.)

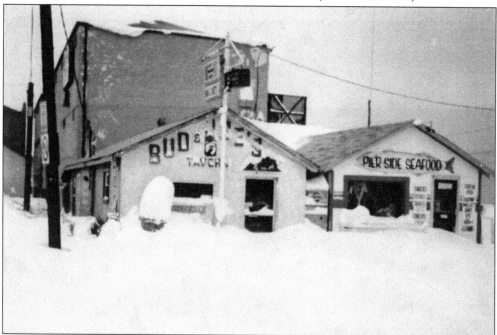

The snow of December 1989 was a shock for everyone. Snow at the beach is always of interest, and the 18-inch snowfall was no exception. This picture shows Bud and Joe's Tavern and the Pier Side Seafood Market. The motel in the background is the Rolling Surf. The Kure Beach Pavilion is located where the Rolling Surf once stood. (Gary Teague.)

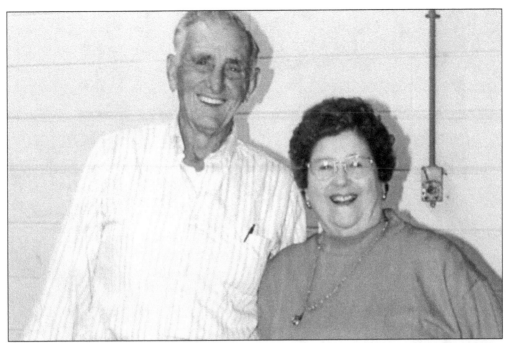

Jay Will "Dub" and Hazel Heglar are smiling for the photographer. Dub was the superintendent of public works for 25 years. Whenever a police chief left, he would be sworn in until a new one was hired. Hazel ran the Ocean View Restaurant (currently Kure Beach Diner) for 10 years. In addition to delicious seafood and desserts, the restaurant served fresh vegetables from Dub's garden. (Thomas Russell.)

Pictured from left to right are Harold, Hazel, David, and Dub Heglar. Harold served as fire chief from 1977 to 2017. David, Harold's son, has served three terms on council. Dub, Harold's father, became a volunteer fireman in 1961 when the fire department was housed with the town hall and police department on Third Avenue. Harold's wife, Diane, has produced many wonderful Christmas musicals using local talent. (Harold and Diane Heglar.)

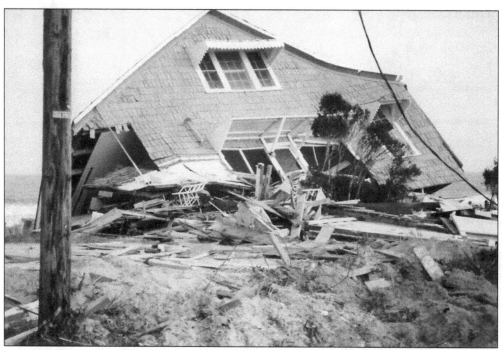

The Bond house was completely destroyed by Hurricane Fran on September 5, 1996. This home had endured 81 years of storms. (Coffey family.)

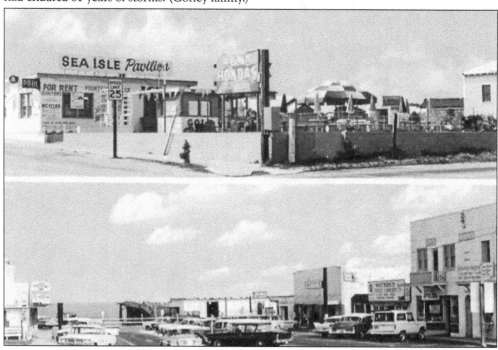

Shown in the 1960s is the Sea Isle Pavilion, owned by Tommy "Big Daddy" Lancaster. The pavilion offered miniature golf, an arcade, snack/soda bar, and scooter and bicycle rentals. The bicycles built for two were a great hit. Sometimes, women tried to ride on the back of the bicycles so that they did not have to pedal and the men could do all the work! (FPHPS.)

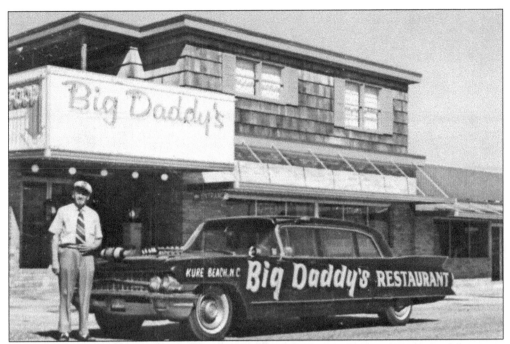

This 1972 postcard shows Big Daddy standing beside his signature traveling-billboard Cadillac. Note the real longhorn hood ornament mounted on the front. Behind him is the original restaurant, which opened in 1963 on the northwest corner of K Avenue and Fort Fisher Boulevard. The restaurant was sold to Joe and Doris Eakes in 1981 and has been in continuous operation since the early 1960s. (Elaine Henson.)

This postcard, dated 1950, shows the Vesta-Rest Apartments, located in the vicinity of 212 South Fort Fisher Boulevard. Mr. and Mrs. J.J. Mohn were the owners, and Mrs. C.B. Brewer was the manager. (Elaine Henson.)

The Vesta-Rest Apartments were incorporated into the Wrenn's motel, owned by Oscar and Anna Lee Lewis Wrenn, in the early 1960s. Anna Lee was Miss North Carolina American Legion in 1947. Oscar served one term on council. They had two sons, Lee and Michael Kim. Lee served as mayor for two terms and six terms on council. (Gary Teague.)

This mid-1960s postcard is of Wrenn's Motel. The back of the postcard shares that the motel was open year-round, had air-conditioning and heat, televisions, and private tile baths. It had 21 units, including rooms, apartments, and cottages, and a 20-by-40-foot swimming pool and was located 100 feet from the ocean. (Elaine Henson.)

Norris and Faye Teague purchased Oscar and Anna Lee Wrenn's motel in 1973. The Teagues renamed it the Sand Castle Inn. The rooms rented for $22 per night. Norris was the only man on the island that served on both Carolina and Kure Beach councils. He served four terms on Kure Beach Council. The Sand Castle Motel was sold and torn down in 2006. (Gary Teague.)

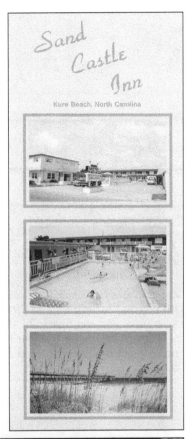

This picture shows the former Sand Castle Inn; it was renamed the Spruce Inn for use in the television series *One Tree Hill*. (Gary Teague.)

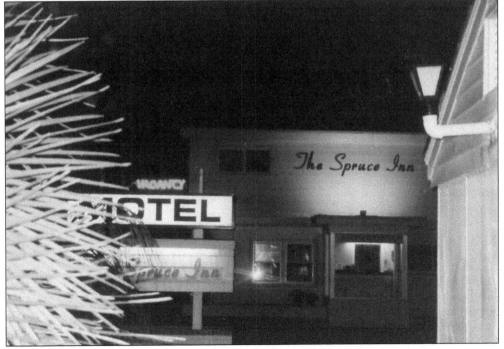

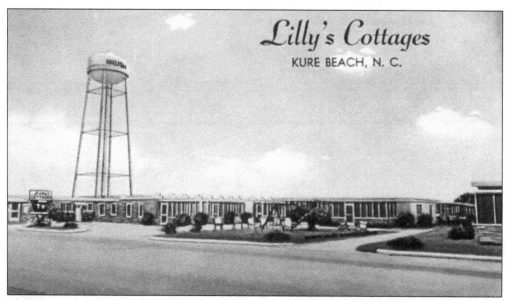

This postcard is dated May 16, 1968, and shows the Lilly's Cottages with the water tower in the background. Phil and Faye Lilly, along with their children, Sylvia, Linda, and Tommy, moved to the beach in 1947. They built the cottages around 1949–1950. Phil served four terms on council. The cottages are located at 133 North Fort Fisher Boulevard and operate now as Palm Air. (Wayne Bowman.)

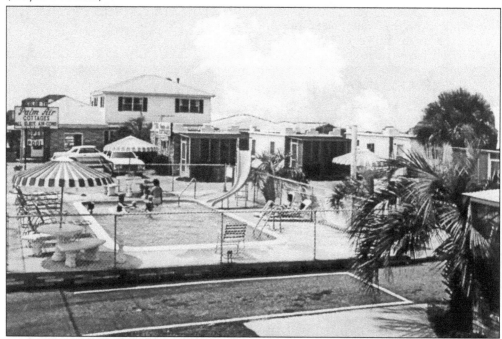

Ed and Linda Lilly Niedens purchased Lilly's cottages in the mid-1970s. Shortly after returning to Kure Beach with their children, Phil, Vicki and Eddie, their mother, Linda, died. Ed operated the cottages alone for several years until he met Ann Efird and remarried. Together they managed the cottages until the late 1990s, when the property was sold. Ed served one term as mayor and one term on council. (Wayne Bowman.)

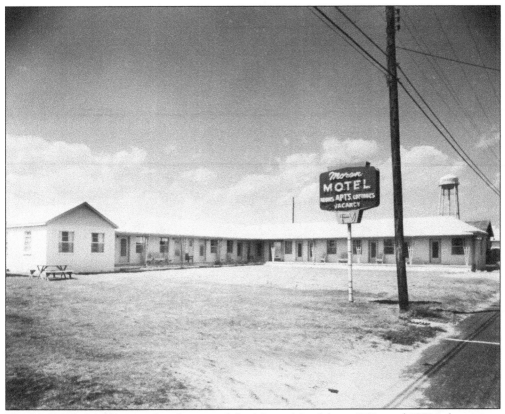

Tom and Viola Moran owned and operated the Moran Motel from 1959 until 1972, when it was sold to Ronnie and Dianna Pernell. This picture was taken in 1960, before the parking area was paved. The motel was located on the west side of South Fort Fisher Boulevard. Tom served one term on council. (Ronnie and Dianna Pernell.)

The Moran Motel was owned by Ronnie and Dianna Pernell from 1972 until 2016. It featured 26 units, electric kitchenettes, air-conditioning, heat, color cable television, and a swimming pool. The movies *Loggerheads*, *Traveller*, and *Final Mafia Marriage* were filmed at Moran Motel. The television series *Surface* was filmed at the home of the Pernells on South Fifth Avenue. (Ronnie and Dianna Pernell.)

Pictured is the original oceanfront Nelson's Motel in the late 1950s. The house was later moved to South Third Avenue, and the motel was remodeled. The back of this postcard states that Howard Nelson was the owner, and his phone number was Glendale 8-5470. (Ronnie and Dianna Pernell.)

This postcard, dated 1968, shows Nelson's Motel at 133 South Fort Fisher Boulevard. The back of the card states, "Modern accommodations with kitchenettes, oceanfront-television-air conditioning-beach umbrellas-surf mats-near pier. Phone 458-5470." Howard and Frances "Fran" Nelson owned and operated the motel from 1956 to 1990. The Sand Dunes is now located on this site. (Elaine Henson.)

This postcard, dated September 1982, is promoting Kure Beach as a "Sun and Fun" destination. The back of card states, "The sun is out. We have been on the beach all day. Tuesday it rained from noon till we went to bed. Very few people here just fishermen." (Elaine Henson.)

This sign welcomes residents and tourists to the quaint Town of Kure Beach. Most important to remember is "Hospitality: Constant." (FPHPS.)

BIBLIOGRAPHY

Robertson, Bill. *Man! You Should Have Been Here Last Week*. Wilmington, NC: Linprint Company, 1982.

Jackson III, Claude V. *The Big Book of the Cape Fear River*. Wilmington, NC: Dram Tree Books, 1996.

Bill Reeves Collection, New Hanover County Library North Carolina Room.

Louis T. Moore Collection, New Hanover County Library North Carolina Room.

Robert Fales Collection, New Hanover County Library North Carolina Room.

Wilmington Star News.

Visit us at
arcadiapublishing.com